C000171555

SECRET
ST HELENS

Sue Gerrard

AMBERLEY

Acknowledgements

I would like to thank and acknowledge all the people and organisations that have helped during the writing of this book. These include Robert Evans for photographs, St Helens Local History & Archives, Friends of Carrington Shaw, North West Museum of Road Transport, St Helens Council Press Office, Steve Wainwright, Brian Leyland and Mary Presland for valuable material.

I would also like to thank the former mayor and mayoress of St Helens, Pat Ireland and Lynn Glover, Chris Coffey and Glyn Davies and everyone who contributed their time and knowledge to this book.

I have carried out extensive research and to the best of my knowledge the facts in the book are correct at the time of publication but apologise in advance if any errors have inadvertently crept in. I also apologise if I have not included any of your favourite items, but the town is so rich in history and, of course, secrets.

First published 2019

Amberley Publishing
The Hill, Stroud
Gloucestershire, GL5 4EP

www.amberley-books.com

Copyright © Sue Gerrard, 2019

The right of Sue Gerrard to be identified as the Author of this work has been asserted in accordance with the Copyrights, Designs and Patents Act 1988.

ISBN 978 1 4456 8974 6 (print)
ISBN 978 1 4456 8975 3 (ebook)

All rights reserved. No part of this book may be reprinted or reproduced or utilised in any form or by any electronic, mechanical or other means, now known or hereafter invented, including photocopying and recording, or in any information storage or retrieval system, without the permission in writing from the Publishers.

British Library Cataloguing in Publication Data.
A catalogue record for this book is available from the British Library.

Origination by Amberley Publishing.
Printed in Great Britain.

Contents

Introduction

St Helens did not exist as a town until the mid-nineteenth century. It was a series of small settlements. These included Eccleston, owned by the Ecclestone family, whose ancestral home dates to 1100; Parr (Parre), a manor owned by the Parr family (Henry VIII's last wife, Catherine Parr, was a distant descendant); Windle (Windhull), which was controlled by the Windle family until it passed to the Gerards of Bryn and Sutton – the origin of this name is unknown, but some say it could mean 'south town'. Several families owned land here, such as the Eltonhead, Ravenhead and Sherdley families. The centre for these four townships became the small chapel of St Elyn, Church Street, from which the town takes its name.

Areas of today's borough appear in historical documents. Newton appears in the Domesday Book of 1086 and gave its name to the local Newton hundred. Local village references are Haydock in 1169, Eccleston in 1190, Rainford in 1198, Billinge in 1202 and Rainhill in 1246.

Coal was a reason why St Helens became a thriving industrial town, and in 1868 a borough. Mining dates back to the 1540s when the four townships were pursuing coal mining. St Helens was well placed on the south Lancashire coalfield, and during the seventeenth and eighteenth centuries coal was supplied by packhorse to the growing port of Liverpool. This gave St Helens a pivotal role in the Industrial Revolution and transport development.

In 1746, the Liverpool to Prescot turnpike road was extended to St Helens and assured the coal industry's success. As industry grew so did the means of transport, and the world's first navigable canal – the St Helens Canal – was cut between 1755 and 1757. In 1829 George Stephenson's Rocket won the Rainhill Trials, and the world's first passenger railway, the Liverpool to Manchester, opened in 1830.

In 1782, John Wesley described St Helens in his journal as a 'small but populous town'. Industry, however, flocked to St Helens, including glassmaking, copper, iron and lead founding and alkali manufacturing. This growth led to an influx of workers and whole areas became known as 'little Irelands' because of the number of Irish people living there. These included Greenbank, Smithy Brow and Gerard's Bridge. In the 1841 census there were 1,000 Irish people in the town, with 600 living in Greenbank. Workers at Ravenhead Copper Works came from Wales and housed in cottages between Watson Street and the canal. This became known as 'Welsh Row'.

As the population grew so did social problems such as health, housing and education. In 1845, John Blundell, a local surgeon, estimated 'fifty cases of typhus per year, per thousand and six or seven people have fallen into the canal and died'. The population of the whole township was 11,800 in 1845. By 1870 the population was 45,000 and St Helens was a thriving and prosperous town – formerly a village of little importance, now the seat

of various branches of industry. However, by 1879 there was said to be '2290 individuals who were dependent for food upon the "Distress Relief Fund".'

The population explosion made St Helens crowded, dirty and unhealthy; there were issues with water supply, housing and sanitation. This led to Queen Victoria granting a charter of incorporation in 1868 and the town became a municipal borough. In 1885, the town returned its first MP, H. Seton-Karr, and in 1889 it became a county borough.

In the 1974 local government reorganisation St Helens incorporated the previous urban district councils of Newton-le-Willows and Earlestown, Haydock, Rainford, Rainhill and parts of Billinge. The town then became St Helens metropolitan borough in Merseyside.

A Chronology of the St Helens Area

c. AD 100	Fort at Newton on the Warrington to Wigan Roman road
c. AD 570	Anglican settlement at Billinge ('place where family of Bylla settled')
c. AD 642	King Oswald of Northumbria dies in battle at Winwick, near Newton
1086	The Domesday Book is written and is the first record of most of the area around St Helens
1100	Beginning of the Eccleston Pedigree (approx.) with Hugh Ecclestone
1212	Adam de Billinge held land in the manor of Billinge
1220–30	Rainhill passed to Roger of Rainhill by the Ecclestons
1246	Rainhill Hall is built
1290	Billinge divided into four sections, one of which became the manor of Birchley
1330	Sir Gilbert de Haydock founded a chantry chapel at Winwick Church
1435	Windleshaw Chantry built by Sir Thomas Gerard of Bryn
1541	First mention of a church at Rainford
1558	First formal mention of St Elyn's Chapel
1567	Eccleston Hall built
1585	St Edmund Arrowsmith, Catholic martyr, born at Haydock
1629	'Ye Olde King's Head', the first public house built near St Elyn's Church, Chapel Lane, now Church Street. Demolished 1878
1643	The Parliamentarians defeat the Cavaliers at the Battle of Winwick in the English Civil War
1648	Cromwell defeats the Duke of Hamilton at Red Bank, Newton/Winwick
1674	Malt Kiln House built at Billinge
1678	Quakers built the Friends' Meeting House, Church Street
1714	Sarah Cowley died. She left most of her estate to further education in St Helens
1721	Foot o'th' Causeway Inn built at Billinge
1726	Liverpool to Prescot turnpike road opens
1730	Red Lion Hotel built in St Helens
1734	First workhouse established
1745	Eagle and Child Inn built at Billinge
1746	Turnpike road from Liverpool extended to St Helens
1752	Stork Inn built at Billinge

1757	Sankey Canal opens. It was built by Henry Berry
1759	Black Bull Inn built in St Helens
1761	Patent granted to Jonathan Greenall of Parr for a newly invented fire engine for draining water from mines, coal pits and land
1762	Thomas Greenall opens a brewery, Hall Street. The Brewery Malt Kiln was built on what is now Kiln Lane
1772	Sankey Copper Works opened in Blackbrook
1773	The British Plate Glass Company opened at Ravenhead
1779	Parys Mountain Company, copper smelters, came here
1780	Copper works opened in Ravenhead
1782	John Wesley, founder of Methodism, preached here
1798	St Helens Foundry established. It was later bought by Robert Daglish
1800	First Wesleyan chapel erected in St Helens
1801	The population of St Helens is estimated at 7,573
1810	Oil lamps used to light the streets
1816	Parish church reconsecrated and dedicated to St Mary
1820	Coaches ran from the Raven, Fleece and White Hart Hotels to Liverpool, Bolton, Leeds and York
1825	First post office opened in St Helens
1826	Pilkington Glassworks begins production
1829	Mr J. C. Gamble's chemical works opens
	The *Rocket* won the locomotive trials at Rainhill
1830	Liverpool to Manchester railway line opened
1832	St Helens Gas Company incorporated by an Act of Parliament
1833	St Helens and Runcorn Gap Railway opens
1839	Old Town Hall built in the Market Place
1840	A detachment of police was formed at St Helens
1841	Peter Greenall became MP for Wigan
1842	St Helens textile factories close due to fumes from chemical works
1844	St Helens Waterworks Company started
1845	Richard Seddon born at Eccleston. He was later prime minister of New Zealand.
	An organisation is formed with the power to pave, clean and light the streets of St Helens
1849	Outbreak of cholera
1852	*St Helens Intelligencer*, St Helens' first newspaper, was published
1854	Cholera breaks out again
1868	St Helens becomes a borough, incorporating the townships of Parr, Eccleston, Sutton and Windle
1871	The old Town Hall burns down
1872	St Helens Hospital, known as the Cottage Hospital, opens
1876	The new Town Hall opens
1877	The Church of Sacred Heart opens
1878	Major colliery explosions at Queen's Pit and Wood Pit, Haydock

1881	First horse-drawn trams run
1882	Peasley Cross Hospital opens
1885	Henry Seton-Karr becomes the first St Helens MP
1887	*St Helens Lantern* newspaper is first published
1889	First steam tram runs
1892	St Helens Museum opens
1893	Land for Taylor Park is presented to the town by Samuel Taylor
1896	The Gamble Institute is opened
1899	Explosion at Kurtz Chemical works
	First electric trains run
	First race under Jockey Club rules is run at Haydock Park
1901	St Helens population is around 84,000
1911	The first cinema opens
1936	The last trams run in St Helens
1971	St Helens' population is around 98,000
1974	St Helens becomes a metropolitan borough
1982	The Hardshaw Centre opens
1986	St Helens Transport Museum opens
2000	The World of Glass opens

1. The Beginnings

The Hearth Tax of 1616 states there were 'twenty-seven houses who have three hearths or more in the township of Windle'. While in 1773 Edward Wilson, secretary of the Plate Glass Company, said: 'St Helens was a small hamlet and that our works were obliged to supply our own people with food ... we had the growing of corn and St Helens was a mere little place of twenty or thirty houses.'

The population of the four townships in 1831 was 14,199. Ninety-six of these were listed as 'Professional or Educated men's' – of these fifty-two lived in Windle and one in Parr.

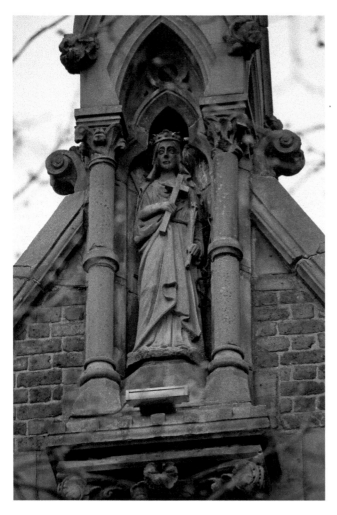

Statue of St Helena situated outside the Town Hall. There is another statue outside Holy Cross Church.

The town's population continued to increase, and it was recorded in 1845 that colonies were beginning to become established, such as the Irish Roman Catholic immigrants who settled in Greenbank.

The name St Helens comes from a chapel of ease that was dedicated to St Elyn and stood in Chapel Lane, today known as Church Street. The earliest documented reference was in 1552, and the first time it was formally mentioned was in 1558. This was when Thomas Parr of Parr bequeathed a sum of money 'to a stock towards finding a priest at St Helens Chapel in Hardshaw and to the maintenance of God's divine service there for ever, if the stock goes forward and that the priest does service as is aforesaid'. In 1552, this chapel was 'consisting only of a challis and a lytle bell' and was the crux of the four townships. The original St Helens Chapel was demolished in 1618.

St Helen or St Helena (c. 250–330) was a Roman empress and mother of Emperor Constantine the Great, Rome's first Christian emperor. Her feast day in the Roman Catholic Church is 18 August. In her final years, she undertook a pilgrimage and is said to have found the True Cross of Christ. This legend was first mentioned by Henry of Huntingdon, but was popularised by Geoffrey of Monmouth who said she was the daughter of the King of Britain, Cole of Colchester. St Helen is the patron saint of new discoveries, archaeologists, converts, difficult marriages and divorced people.

Discovery of Coal

The first record of coal gathering was in 1556 on the Eltonhead land: 'beds of cinders or coke ... have been discovered three-foot-thick during the digging of clay'. In 1580 mining was underway at Burtonhead, where an estate plan showed one area as 'Pemb[er]tons Cole Mynes'. These were shallow pits and the coal was removed by shovel and pick, an early form of open-cast mining.

The Industrial Revolution fed the need for coal. This, coupled with transport improvements, meant coal was a lucrative investment. This investment meant the coal industry could advance and take advantage of the newly invented steam engine and steel wire ropes, which allowed them to go deeper underground.

Early investor Charles Dagnall was operating Barton's Bank Colliery in Sutton/Watery Lane in 1750 and built a Newcomen engine here. In 1839 the mine was put up for auction at the Raven Inn, Church Street, but there is no evidence of it being worked after then. Sutton was home for a legion of new pits, including Sherdley, Lea Green, Bold, Clockface and Sutton Manor, which all opened between 1873 and 1901.

A leading name in mine ownership was Richard Evans (1778–1864), a London printer. In the 1830s most of the collieries were on land owned by the Leghs of Lyme and were run by Thomas Legh and William Turner. Richard Evans bought Legh's share and when Turner died in 1847 Evans acquired it. The firm became Richard Evans & Sons and remained a family business until 1889. Richard Evans' name lives on in Haydock with Richard Evans Community Primary School and Evans Close.

The Mucky Mountains, Earlestown, 1985.

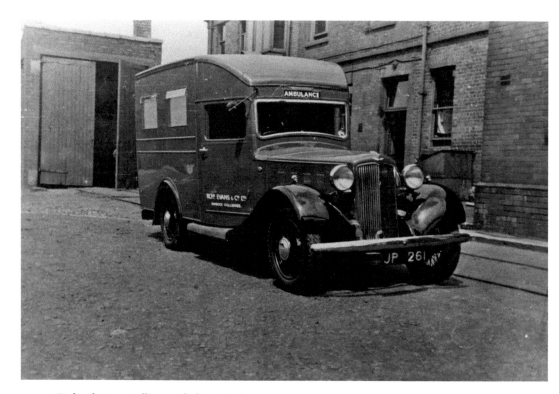

A Richard Evans Colliery ambulance in the 1930s.

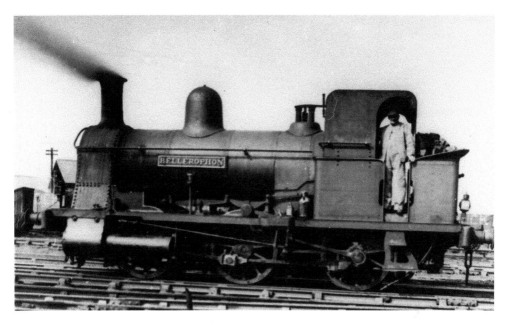

The Bellerophon, a Richard Evans locomotive built for the Haydock Colliery in 1874, photographed *c.* 1880.

DID YOU KNOW?
In 1819, St Helens Colliers went on strike for what is thought to be the first time. Troops were called in to quell the disturbance.

Working in the mines was a treacherous job. Men, women and children died in roof falls and explosions, with firedamp gas being the cause of most disasters. One of the worst disasters was the Wood Pit disaster (June 1878) at Haydock, which claimed 198 lives.

One of the mining monuments is *The Landings* in the roundabout at the Landings Junction, North Road. It was installed in 1995 and portrays a pick-swinging miner, pit brow lass and young pit lad set against a coal pillar and mounted on local stone. *The Miner*, also known as the 'Anderton Mining Monument', is on the roundabout at the junction of St Helens Linkway and A58 near the former Ravenhead Colliery. It is Grade II listed. The statue illustrates the pioneering role Ravenhead Colliery had in developing the Anderton Shearer Loader, which was eventually used worldwide. *The Dream,* opened in 2009, is on an old spoil tip of Sutton Manor Colliery and overlooks the M62 motorway. This 66-foot girl's face was created by Jaume Plensa, cost around £1.8 million and was funded by the Big Art Project in co-ordination with the Arts Council, England, the Art Fund and Channel 4 television.

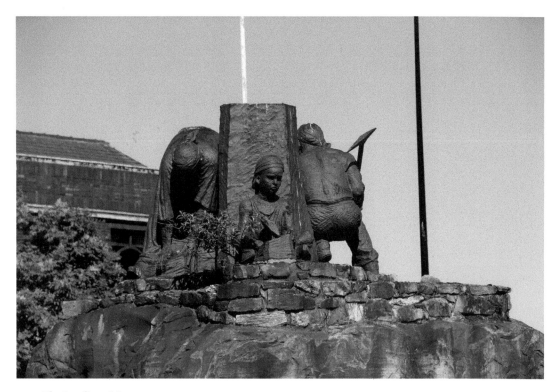

The Landings Monument.

DID YOU KNOW?
The Duckeries was once a slag heap but has now returned to its marshy origins and has the Green Man installation.

Ex Terra Lucem

In 1876, the town's original coat of arms was granted and includes representations of the Ecclestone, Gerard, Bold, Parr, Walmsley, Gamble and Haydock families. This was used from 1876 to 1974.

The Latin motto *Ex Terra Lucem* literally means 'From the Ground Light', but is also known as 'Light out of the Earth'. This refers to the abundant coal resources burnt to give light and its use in local industry such as glass, through which light passes.

In 1974 there was a new crest. Changes included references to the Pilkington family, representing Windle, Billinge, Newton UDC and Haydock UDC and the seven constituent authorities that make up the borough are denoted.

In 1974 the motto became *Prosperitas in Excelsis*, which means 'success in the highest' or 'flourishing well'. However, after the 2012 Olympics the creative writer of the opening ceremony, St Helens' Frank Cottrell-Boyce, said the town's original motto was a

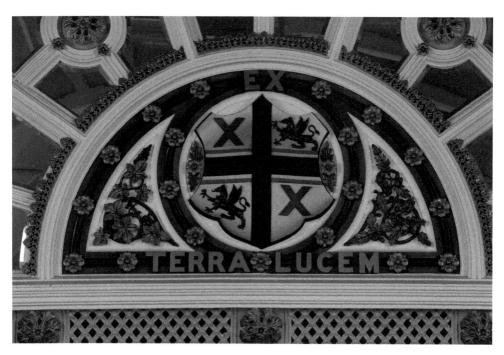

St Helens crest displayed in the Town Hall.

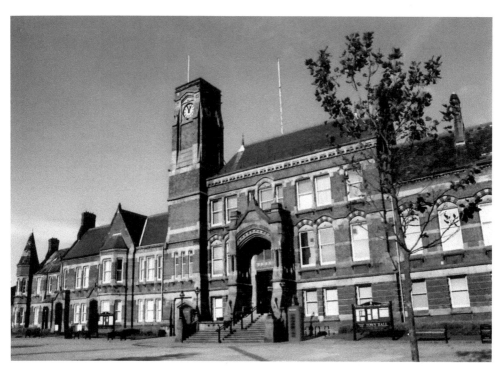

The Town Hall was the result of the vision and work of Peter Greenall, who contributed to the building fund.

considerable influence behind the Olympic cauldron. The success of the games led to the readoption of the original motto.

MPs

Henry Seton-Karr (1853–1914), the town's first MP, was educated at Harrow and Oxford University where he gained an MA in Law. He was an explorer, hunter and author and owned a cattle ranch, Pick Ranch, in Wyoming, America. He was a Conservative. Elected in 1885, he held the seat until defeated at the 1906 general election. He died aged sixty-one in Canada's greatest maritime disaster when the *Empress of Ireland* sank in the St Lawrence River.

DID YOU KNOW?
First MP Henry Seton-Karr wrote an article called 'How I shot My Lions', which was published in 1900.

These are the other MPs who have represented the town: Thomas Glover, miner and labourer served as MP from 1906 to 1910; Conservative Sir Rigby Philip Watson Swift, a lawyer then judge, represented the town from 1910 to 1918; James Sexton followed in 1918 to 1931; Richard Austin Spencer from 1931 to 1935; and William Albert Robinson from 1935 to 1945.

Hartley William Shawcross was the Labour MP from 1945 to 1958 and was the lead British prosecutor at the Nuremberg War Crimes tribunal. He was appointed attorney general from 1945 to 1951 under Prime Minister Clement Attlee. It was in this role that he prosecuted William Joyce (otherwise known as Lord Haw-Haw) and John Amery for treason, Klaus Fuchs and Alan Nunn for giving atomic secrets to the Soviet Union. He was also the prosecutor the trial of John George Haigh, who was known as the 'acid bath murderer'. He died in July 2003 aged 103.

Leslie Spriggs succeeded him from 1958 to 1983 when St Helens North constituency was created, giving St Helens two sitting MPs.

John Evans represented St Helens North until 1997 when David Watts succeeded him, followed by Conor McGinn in 2015. Gerry Bermingham represented St Helens South from 1983 to 2001 when Shaun Woodward was elected. He served until 2015 and was followed by St Helens' first female MP, Marie Rimmer in 2015.

2. Transport Mania

In the seventeenth century, coal was transported by packhorse to Cheshire's rock salt industry and to Liverpool. However, the roads were unsuitable for the growing demand of coal from Liverpool, so the Liverpool to Prescot turnpike road was extended in 1746. Many coaching houses were built such as the Running Horses, which was en route from Liverpool to Warrington, where passengers stopped for refreshments. Probably built in the late eighteenth century, the earliest recorded licensee was James Bridge in 1790. It later became a Greenall's pub and closed in April 1964. Today it is the site of the modern Running Horses, Chalon Way.

However, the waterway/canal age was coming, and St Helens was to play a momentous role with the Sankey Canal. There had been other successful navigable waterways created before the Sankey Brook Navigation: the River Weaver (1733), Rivers Mersey and Irwell (1730s) and River Douglas (1742). Two men were chiefly responsible for the Sankey Canal. The first was John Ashton, whose father Nicolas died in 1728 and who had estates in Ashton, Parr and Eccleston. John was the financer-in-chief for the project. The second was surveyor Henry Berry, who had been born in Parr in 1719/20. In 1743, he acted as a surveyor for Parr and his input was regularly recorded in documents relating to this township. By the age of thirty he had been entrusted with completing Liverpool's second dock. In 1753, he still maintained his links with the town and became a trustee of the Independent Chapel. He died in Liverpool aged ninety-two and had requested his body be carried to the chapel and buried in the graveyard. William Taylor assisted Henry Berry in surveying the canal and they were paid £66.

The canal is also known as the Sankey Canal or St Helens Canal and opened in 1757. It was England's first modern canal as, unlike the developments before, it did not upgrade an existing river but used an independent channel of water. The nearby Sankey Brook supplied the necessary water and took the overflow when required. It was also the location of the country's first double canal lock.

Eventually it was extended to Fiddler's Ferry, Widnes, Sutton and close to today's town centre. For the next seventy-five years the St Helens area would be dominated by the canal.

An early steam-power trial took place on 16 June 1797 (Billing's *Liverpool Advertiser*) when John Smith's vessel full of copper slag sailed along the canal and returned later that evening. It was powered by the Thomas Newcomen engine.

Eventually its main cargo became raw sugar destined for the Sankey Sugar Works at Earlestown, Newton-le-Willows, but the decline of the sugar transportation led to the closure of the canal in 1963. It is still visible in St Helens town centre, although it was truncated in 1898 when Canal Street was constructed over it.

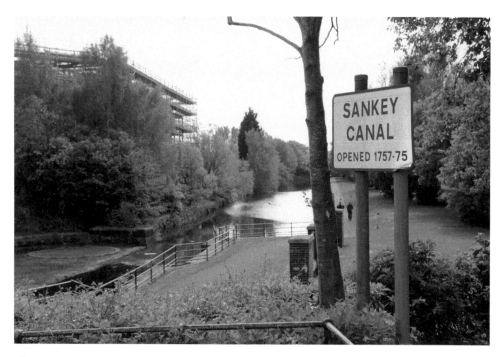

The Sankey Canal.

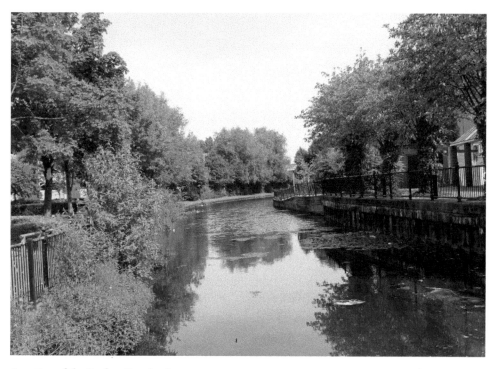

A section of the Sankey Canal today.

In 1985 the Sankey Canal Restoration Society (SCARS) was formed with the support of the St Helens Groundwork Trust. The society's aim is the full restoration of the 'first canal of the Industrial Revolution'.

The crossing point at the Nine Arches, Newton-le-Willows, is a unique place in the world as it is where the world's first navigable waterway/canal, the Sankey Canal, crossed the world's first passenger railway, the Liverpool to Manchester line.

Next came the railway age, and St Helens was to play a leading role with the Liverpool to Manchester line. The beginning of this line goes back to Joseph Sandars, a wealthy corn merchant from Liverpool, and John Kennedy, owner of Manchester's largest spinning mill. The encouragement for this project came from a rich property speculator called William James; the Liverpool and Manchester Railway Company was founded in May 1824.The main engineer was George Stephenson. The Rainhill Trials took place in October 1829 on flat land between Rainhill and Lea Green stations. These trials were to find the fastest, most reliable steam engine. It was the *Rocket,* designed and built by George Stephenson with his son Robert and Henry Booth, that won.

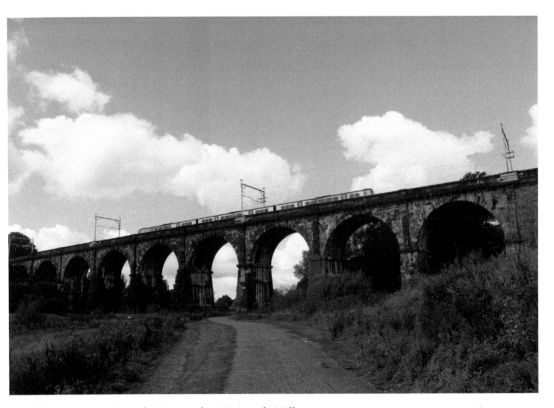

The crossing point at the Nine Arches, Newton-le-Willows.

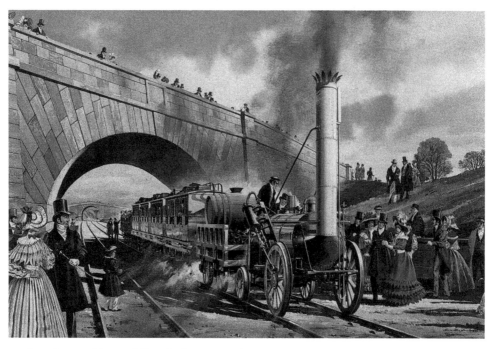

A coloured print of the Rainhill Trials showing Stephenson's *Rocket*.

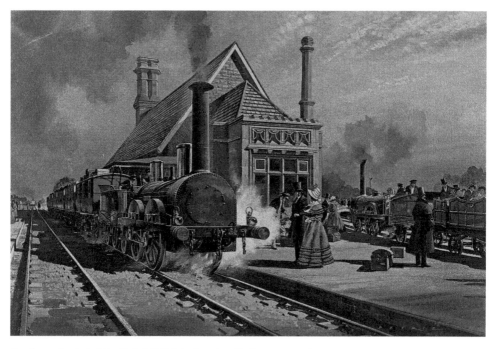

A coloured print of the Rainhill Trials showing Earlestown station.

The Huskisson memorial.

The Liverpool to Manchester line opened on 15 September 1830 and became the world's first passenger train service as it relied only on steam power, unlike the Stockton to Darlington line, which used steam and horse-drawn traffic. It was also the first to be double tracked throughout, have a signalling system, be fully timetabled and the first to carry mail. The line required a total of sixty-four bridges or viaducts – a feat of engineering. The grand opening was marred by tragedy when William Huskisson, MP for Liverpool, was killed, becoming the first fatality of the railway age. A memorial to him stands at Newton-le-Willows station on the south side of the line, around 60 metres from the road.

DID YOU KNOW?
St Helens Junction station is one of the world's oldest, dating back to 1830 when it was known as the Bottom of Sutton Incline (it changed its name in 1832/33). People used to approach it from Monastery Lane via Pudding Bag Bridge.

The St Helens Railway was originally known as the St Helens and Runcorn Gap Railway and was an early railway company, which opened in 1833. It was taken over by the London & North Western Railway in 1864.

It was built in response to the growing demand for coal to be transported to industries in the North West, and in 1829 Charles Blacker Vignoles carried out a survey of the intended line. Originally the line was to run from Cowley Hill Colliery via Greenbank, Sutton Hall and Lea Green to a dock on the River Mersey. However, this was changed to a more easterly route so that it crossed the Liverpool–Manchester railway by bridge, stopping at local collieries on the way.

In November 1832 the first train wagons went from Broad Oak Colliery to the River Mersey and the line officially opened on 21 February 1833. The line was originally intended for freight but began a passenger railway as well in September 1833 due to public demand. The railway company extended its routes so that by the 1860s it was possible for people to travel eastwards from Runcorn Gap to Warrington, and from there to Manchester, London and other destinations.

In 1923 the line from St Helens to Widnes became part of the London, Midland & Scottish Railway (LMS) and large quantities of freight and a passenger train from St Helens to Ditton Junction station was in operation. This was nicknamed the 'Ditton Dodger' and the service was to end on 16 June 1951. The freight traffic declined, and the line was to close on 1 November 1981.

St Helens had transport links nationwide, but as the town expanded there was a demand for better transport within the town. The town extended northwards to Windle City, north-west to Dentons Green, west of St Ann's and Toll Bar, south of Robins Lane and St Helens Junction and east of Blackbrook.

In order to fulfil this need, the St Helens and District Tramways Co. Ltd was founded. The first horse-drawn tram service – between Ormskirk Street and Prescot – ran on 5 November 1881 and was hourly. The trams were open-topped double-decker's and the horses were stabled at the Feathers Hotel on the corner of Eccleston Street and Westfield Street.

Steam trams were the next development, and were authorised under the St Helens and District Tramways Act 1883. However, the original tram company could not meet the expense of the new trams and declined. In 1889, the St Helens and District Tramways Co. Ltd was formed and the first steam tram was introduced that year.

In 1887, St Helens Corporation bought the tramways but leased it to the tramway company and work on electrisation began in 1898; in preparation for this change the Hall Street Tram Depot was widened the same year. The first electric trams, running under overhead wire began, in 1899; by autumn there were thirty-six trams in operation. From 1907, electric trolleybuses running on tyres were also added. In 1919, St Helens Corporation took over the tramway company and by 1923 a single-deck tram began to run between Sefton Place and Windle City.

Trolleybuses were next with the added benefit that much of the tramway infrastructure could be used by them. In 1948, all the trolleybuses were double-deckers but by 1952 these were being replaced by the motorbus. The trolleybuses ceased to run in 1958.

The North West Museum of Road Transport (St Helens Transport Museum), Hall Street, started as a horse tram depot from 1881 then became a steam tram depot (trams

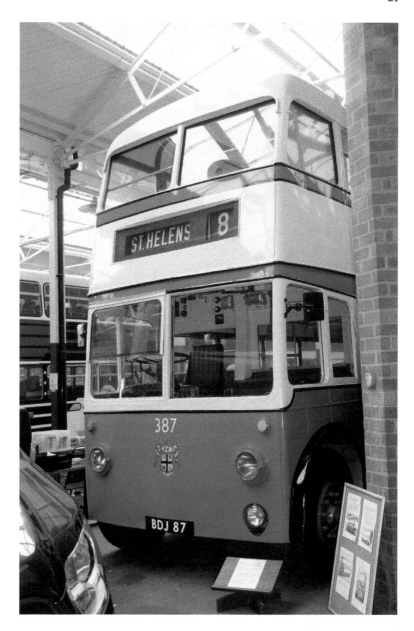

Trolleybus
No. 387.

DID YOU KNOW?
Before the advent of cars coach travel was a popular mode of transport, but there wasn't enough room to keep up with demand. Therefore, travellers bought their own coach for around £90. It was called *The Regulator*.

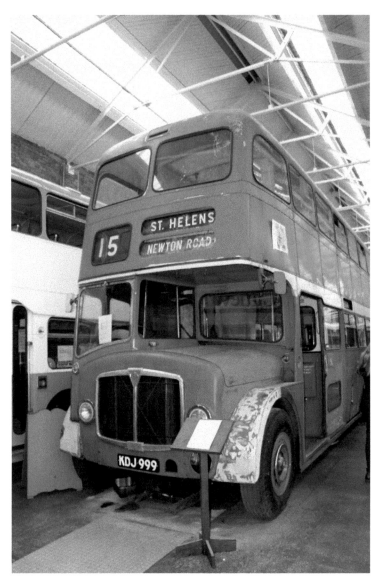

St Helens No. 15 bus.

hauled by small steam locomotives) from 1890 until 1900. It kept pace with transport changes and in 1929 the Tolver Street section of the building opened as a bus depot and was then converted into maintenance workshops. As petrol, then diesel, buses were added it became a diesel bus garage for St Helens Corporation and Merseyside Passenger Transport Executive. In the mid-1960s a new bus depot opened in Jackson Street and the old depot became a maintenance depot. However, when new longer buses proved to be problematic when it came to accessing the old depot, new workshops were built at Jackson Street, opening in 1984. The building was leased to the museum in 1986.

The museum started in the 1960s when a group, later the St Helens Transport and Trolleybus Society (STATS), bought a former St Helens Corporation Trolleybus to

preserve. As they bought more vehicles, they hit the problem of where to put them. The first solution was to rent a hangar at Burtonwood airfield. As this expanded STATS became the North West Transport Museum Society and then the North West Museum of Transport Ltd, which runs the current museum in Hall Street.

It has tram tracks and former inspection pits. The steep staircase at the back of the single-floor building originally led to the hayloft for tram horses and the downstairs room was originally stables.

Among the St Helens vehicles here are the British United Traction electric trolleybus No. 387, which operated in the latter years of the St Helens system. It is the sole example to survive.

CDJ 1954 Leyland TitanvPD2/9 D. J. Davies (Pontypridd) double-deck, formerly St Helens Corporation E78, was made especially for St Helens. It was known as 'Big Bertha'.

The KDJ 199 1959 AEC Regent V, East Lancs (Blackburn) seventy-three-seat, front entrance double-deck, formerly St Helens Corporation K199. It was the biggest bus in the

This steep staircase leads to what was once a hayloft.

fleet and the only front-entrance bus, which caused confusion for some passengers who tried to board from the back.

The museum has regular events including the opportunity to travel around St Helens on a selection of these buses.

St Helens is served by motorway links with the M58 and M62 to the north and south, and the M57 and M6 to the west and east. Other notable roads are the A580 East Lancashire Road, built between 1929 and 1934 and opened by George V. The Rainford Bypass and St Helens Linkway are classed as part of the A570 and both important parts of the St Helens road network.

A Jowett car, *c.* 1900.

DID YOU KNOW?
The 1960 Leyland Titan, once No. 175 in St Helens Corporation fleet, was the first bus to have a modernised radiator grille, known as a 'St Helens Front'. Following its removal from service in 1972 it became the first big-fleet bus to be converted for wheelchair access.

3. The Industrial Town

In 1700, the four townships were mainly agricultural – tilled fields existed, as did arable and pasture farming. The gaps in the farming fields were given place names such as 'heath' and 'moss' that still exist today – such as Thatto Heath and Moss Bank.

Sometimes fields and waste patches showed evidence of coal mining, such as coal banks, which had already started in a small fashion. Small-scale businesses included glassblowing, comb making, and brewing was almost a home industry.

By 1750 coal had replaced wood as fuel for the Cheshire salt field, raising the importance of St Helens and its coal.

Growth of Industry

An early business was that of John Leaf Sr, who died in 1713 and was recorded as a glassmaker of Sutton, a business that continued to at least the 1730s. The canal age brought an industrial giant here in 1773 when the British Cast Plate Manufacturers was incorporated by Act of Parliament. Naval commander Admiral Philip Affleck (c. 1726–77) was a founder. The first plate glass in the country was manufactured at the Ravenhead factory at the end of the Sankey Canal, and for many years this was the largest glass works nationwide.

The Crown Glass Works, Eccleston, belonged to Mackey and West and passed to Pilkington's around 1851. Thomas West's bottle works at Thatto Heath was demolished around 1856. St Helens Crown Glass Company was established in 1826 and among the partners were Peter Greenall and William Pilkington, a name that was to become synonymous with glassmaking worldwide. William Pilkington was the great-grandson of Richard Pilkington of Horwich, near Bolton, and was apprenticed to William Fildes, a St Helens doctor in around 1781. In April 1786 he qualified in London as a doctor and after two years he was back in St Helens. In partnership with John Walker they took over the practice of Dr Fildes, who had died.

William Pilkington married Ann Hutton and two of their thirteen children – Richard, born 1795 and William, born 1800 – were the Pilkington Brothers, who made St Helens a global success in the glass industry.

This success, however, can be traced back to Sir William Pilkington who was also an apothecary and kept a shop that sold wines and spirits. Even when he retired from medicine in 1813, he still maintained the shop. His two sons were to join him in this enterprise, which became William Pilkington & Sons.

It was so successful they began to rectify and compound the spirits themselves and built a successful plant at the junction of Bridge Street and Church Street in 1832. However, it was the marriage of William Pilkington's daughter, Eleanor, to brewer Peter Greenall in

1821 that brought important industrial changes. The amalgamation of these two leading business families paved the way for Pilkington Brothers.

Continental advances in glassmaking were adopted by the company, such as in 1841 when Pilkington's started to make German sheet glass. By the end of the nineteenth century bottle, plate and crown glass were being manufactured here. In 1845 they became known as Pilkington Brothers and in 1894 they became Pilkington Brothers Ltd. From 1953 to 1957 Sir Alastair Pilkington and his team invented the 'float glass process', which revolutionised glass production worldwide.

Today the company is called Pilkington Group Ltd and is a subsidiary of the Japan-based NSG Group.

Forster's Glass Co. Ltd was founded by John Forster, who was born in 1853 at Parr Mount. He was apprenticed as an engineer at Robinson Cook & Co., Atlas Street, and in 1876 he went to the boiler-making department. Two years later, in partnership with his elder brother, he founded D. & J. Forster, Navigation Boiler Works, in Bridgewater Street, which was dissolved in 1890. New premises were acquired in Atlas Street, where the work spanned constructional engineering, boiler making and in later years glass bottle production. Following John Forster's death in 1927 his sons ran the business until it was

Pilkington's striking blue and white head office on Prescot Road was completed in 1964 and still dominates the town.

absorbed by Rockware in 1968. The factory closed in 1982 and is now part of St Helens College known as the Waterside Campus.

The copper industry came here in the shape of Messrs Hughes, Williams and Co. Copper Works. These were Edward Hughes, Thomas Williams and John Dawes, a London banker who established the Parys Mine Company at the side of the Sankey Canal in 1780. Copper was brought here from Anglesey to be smelted into copper ore. Michael Hughes, younger brother of Edward, became manager and later bought St Helens Lodge.

Similar industries flocked here such as Belvoir Mining Company (1831), Staffordshire Company (1832), John Bibby & Sons and Co., St Helens Copper Company and John Marsh all set up at Ravenhead.

Copper wasn't the only metal industry to come here as iron and brass foundries soon followed. Foundries were essential for other industries, which required steam engines, boilers, large castings and wrought-iron beams, and they became a much-needed commodity.

Messrs Lee, Watson and Co. opened the St Helens Foundry in 1798 with Robert Daglish Sr, probably the partner of Lee Watson. It was his son also Robert Daglish who started working here in 1830 and helped the factory outstrip its rivals.

Demolition work in Foundry Street in 1986.

Foundry Street today.

It is thought the first brewery belonged to Edward Greenall at Parr Stocks with the malting taking place at Hall Street, which had a kiln that dated back to 1762. However, the oldest kiln in the town was a malt kiln in Kiln Lane, dating from the beginning of the eighteenth century.

Another successful brewer was William Hill, who sold his business to Charles Speakman of Church Street. He had a small brewery in Market Street and when he died in 1844, aged forty-five, his widow continued the business until 1864 when it was bought by Greenall, Whitley and Co., who were to become brewing giants.

Greenall's Brewery founder was Thomas Greenall, born in 1733. He married Mary Turton in 1754, part of the Parr Stocks brewing family. When his father-in-law John died, he took over the firm.

He opened a brewery in Hall Street in 1762. It was so successful that Thomas and Mary moved to Hardshaw Hall, near his brewery, in 1805. His three sons, Edward, William and Peter, would go into the business. When Thomas died in 1805, Edward (b. 1758) became senior partner and much later was tasked with running the St Helens site. This site closed in April 1975 and is now the site of the Hardshaw Centre Shopping complex. The brewery's logo can be seen on the Hardshaw Centre's wall in Church Street. The brewery still operates at the Wilderspool Brewery, Warrington.

Although St Helens was well known for brewing and public houses, it did have temperance bars, such as Johnson's in Liverpool Road. In line with this, John Kerr brewed his own barm beer, which he delivered to customers on his shoulders in 1864. He started in Baldwin Street and his aim was to provide non-alcoholic drink for the public.

Pioneer Josias Gamble brought the chemical industry here when he erected his factory on the side of the Sankey Canal. He was joined by Mr James Muspratt but this partnership only lasted two years.

In 1830, a blind solicitor, Edward Rawlinson, opened a Gerard's Bridge works for making 'alum' from 'warrant', which was obtained from the Cowley Hill coal pits. This business failed and was sold to Josias Gamble and James Cosfield, a soap manufacturer from Warrington. Similar businesses followed including James Clough of Greenbank and Andrew G. Kurtz.

DID YOU KNOW?
Andrew Kurtz studied chemistry in Paris after having fled from his hometown of Reutlingen, Wurtemburg, during the French Revolutionary War. When Napoleon fell, he went to America where he became an American citizen and later came to England, finally settling in St Helens.

Beecham's Pills were renowned throughout the world and this highly successful business came to fruition in St Helens. It was founded by Sir Thomas Beecham (b. 1820), a former Oxfordshire shepherd who first settled in Wigan in 1847. He was granted a medicine licence and sold Beecham's Celebrated Herbal Pills as he worked as a druggist and grocer. In 1858/9, he moved to No. 12 Milk Street, St Helens, and sold pills on the Westfield Street market. He moved to No. 32 Westfield Street where he established his business and was joined by his son, Joseph Beecham, 1st Baronet (1848–1916). 'Worth a guinea a box' was one of their best-known slogans.

The business outgrew its premises and work began on a new building – the world's first factory constructed to manufacture medicines. It opened in 1877 and was one of the first to use electricity. With some major extensions, Beecham's became the iconic building of today, complete after its baroque clock tower. These extensions swallowed up Silver Street. The factory closed in 1998 and is now part of St Helens College.

Tontine Street was home to a sailcloth factory owned by Thomas and William Kidd in 1820. It closed in the 1840s. The cotton industry existed here until the 1841–43 depression. The first factory, owned by brewer Thomas Greenall, his brother Richard and Thomas Eccleston, built a water-frame spinning factory in Eccleston township.

The Beecham Building.

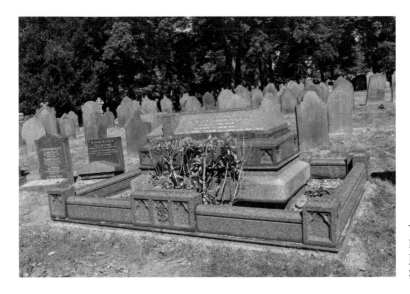

The grave of Sir Joseph Beecham and Lady Josephine Beecham in St Helens Cemetery.

Growth of the Town

The town's first completely new street, in terms of habitation, was Tontine Street. It was built in 1797 by the St Helens Tontine organisation, who wanted to have financial rewards from this venture – hence the name of the street. It had a series of cottages and was later to link with Market Street and Church Street. These streets and Bridge Street were built

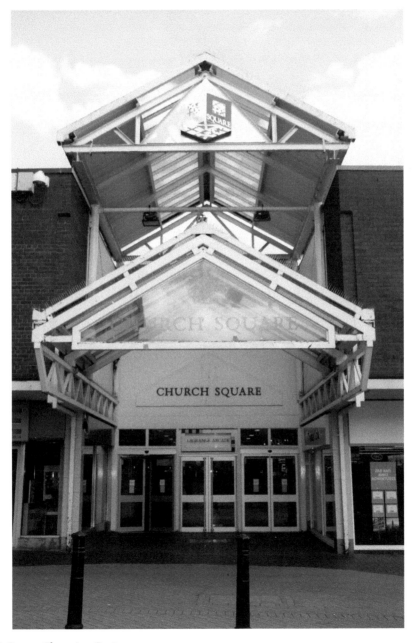

Church Square Shopping Centre.

around a large field, which remained unoccupied until 1833 when owners the Society of Friends created a central square and sold off the remaining land. This was the New Market Square, which became the centre for St Helens townships. Accommodation for incoming workers led to an increase in the housing stock and in 1824 the first St Helens Building Society opened.

The provision of water was important. St Helens Brewery had its own water supply, fed by Eccleston Brook. In 1824, owner Peter Greenall laid pipes to supply the four main streets and Moorflat. As the town grew there was greater demand for clean water, and this need was met by the St Helens Improvement Commission.

St Helens Gas Light Company was a privately owned company based in Sutton and incorporated by Act of Parliament in 1832 when shares were floated. It supplied the town with gas for nearly fifty years before being taken over by St Helens Corporation in 1875 who supplied the Town Hall, Technical Institute, Free Library and other buildings with electric light. Works were built between Warrington Old Road and Warrington New Road, with three extensions carried out before 1908. A waterless gasholder was added in 1931 and it was further extended in 1946. In 1949 it became part of the South Lancashire Group of the North West Gas Board.

Law and Order

The upkeep of the law was in the hands of the local community up to the 1830s. Every town in the country had a constable and the St Helens police resources consisted of a rundown lock-up at the Raven Inn. There were also stocks at the end of Market Street for transgressors.

However, with the growth of the town this had to change and in 1837 a meeting was held to discuss the rebuilding of the town's bridewell/prison. In addition, the petty sessions were moved from Prescot to the Raven Inn, St Helens, and were held monthly. The first session was held in February 1838, but magistrates were unhappy with the Raven Inn. When the Town Hall was built opened in 1839 it housed a courtroom, bridewell, commissioner's office and constable's house. It was also home to the Mechanics' Institute and the town's first public library.

DID YOU KNOW?
One of the strangest crimes in St Helens was when the stocks in Market Street were set on fire. Even stranger was a break in at the bone vault in St Helens Parish Church – the bones and skulls were arranged in a bizarre fashion.

The Police Force

Shortly after the formation of the Lancashire County Police Force a detachment was formed in St Helens in 1840 and was commanded by Superintendent Storey. St Helens Police Force and Fire Service were combined at the end of the nineteenth century under the direction of a chief constable. Constables were allocated to fire duty under the control of an officer.

St Helens Borough Police was formed on 1 July 1887. The chief constable from 1887 to 1904 was James Wood, who commanded a force of ninety-five. His successor was Mr Ellerington and it was under him that the CID department was established and police stations at Sutton and Thatto Heath were opened. A mounted branch of the police was established in 1908, and in 1909 they started to patrol the town.

During the First World War the force numbered 135, along with eighty-three special constables. It was in the 1930s when motor vehicles and wireless communication were introduced. Mr Ellerington died in office on 27 February 1939 and was succeeded by Arthur Cust, who oversaw the war years and the increase of motor car patrols. The next chief constable was George Symmons, who was responsible for the building of substations and the end of the police box system. In 1964, Archibold Atherton was appointed chief constable. During this time traffic problems were on the increase and crime was rising. In order to reduce these problems, he introduced mini vans, panda cars and beat constables were given radios. On 29 March 1969, St Helens Borough Police was amalgamated with Lancashire Constabulary, and on 1 April 1974 it became a division within Merseyside Police.

Police constables were at risk in following their duty and sometimes this resulted in murder as in the case of Police Constable James Gordon who was murdered in 1893, aged twenty-six. On 13 November at 11.30 p.m. he and PC Whalley were on duty by the engineering works of John Foster & Co. when they heard someone in the hen roost there. They discovered that there were intruders and, upon entering, they found three men

The police parade yard today.

inside. A fight followed and Gordon was knocked to the ground by a blow to the forehead by an iron bar that one of the men was wielding and then he was kicked in the head. Whalley had managed to apprehend one of the men and another man was apprehended the following morning. Constable Gordon's head was dressed by Dr Jamieson and he was then sent home, where he died the following morning. The accused were John Carney (nineteen) of Mount Street, John Leahy (twenty-two) of Frazer Street and James Riley (thirty-two). All three were colliers. Initially they were sentenced to death, but this was commuted to fifteen years' penal servitude.

In 1905, PC Adams of the borough police force was walking his beat when he encountered a well-known poacher in Boundary Road – David Earp – waving a gun around. As Adams approached, Earp ran down an alley and when Adams gave chase he was shot just above the heart. Adams, although wounded, managed to drag himself back to the road where some passers-by helped him into the Nag's Head Hotel from where he was taken to St Helens Hospital.

Earp had run off down Knowsley Road where he waited in bushes near Eccleston Police Station for another policeman to come past. It was just before midnight when he shot Constable Howells of the Lancashire Police. The policeman was shot in the shoulder and was further stabbed in the face, wrist, back and head when he tried to apprehend Earp. Howell's attack had been a case of mistaken identity; Earp's intended victim was one PC Hulme.

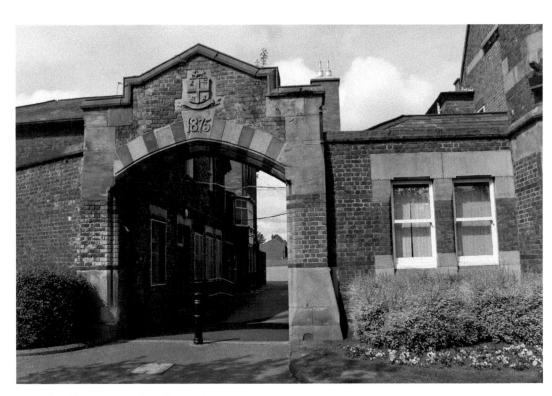

The old entrance to the police station.

In order to apprehend Earp a description was issued: he was forty-nine and lived in Silkstone Street. He was said to be 5 foot 4 inches with sandy hair turning grey and blind in one eye. Despite an offer of a reward Earp was never seen again.

DID YOU KNOW?
The town's first regular policewoman was Sergeant Ethel Van Schaick, who was appointed in April 1946. She had been a member of the Women's Auxiliary Police Corps during the Second World War.

Initially fire protection was shared between public service and private industry. That is, until the government Acts in 1707 and 1774, which required parishes to supply horse-drawn engines, horses and ladders, although some insurance companies formed their own brigades. In the 1820s and 1830s towns nationwide formed their own brigades, and in the 1830s a hand-drawn manual fire engine and two water carts were recorded as being used in the town. In 1858 a Fire Brigade Committee was established and the following year they employed firefighters, although they doubled as police constables. In 1863, the first fire brigade superintendent was appointed. Early fire engines were either horse drawn or pulled by a team of men and were housed in Parade Street behind the Town Hall. Families of firefighters lived nearby for quick access to the engines.

In 1876, the brigade came under the Water Committee and a two-bay fire station was opened in the new Town Hall with an entry in Parade Street – the horses were stabled next door. There were three full-time fireman and a superintendent living nearby.

In 1894, the brigade was reorganised under a Watch Committee. Chief Constable James Wood had a mix of police officers and civilians as firemen. It was reorganised again in 1910 and became a full police fire brigade. In 1911 they obtained their first motor engine.

The Auxiliary Fire Service began in 1939 and was to become the National Fire Service. Following the war, the service returned to the local authority. Pilkington Brothers and Greenall Whitley, however, had their own fire brigades.

The brigade became part of the National Fire Service, with headquarters at the Elms, Cowley Hill and remained there until 1948 when St Helens County Borough Fire Brigade was formed and the station returned to its former home in Parade Street.

In 1959, the Parr Stocks Fire Station opened, and in 1972 the Millfields Fire Station opened and the Parade Street station closed after ninety years. In 1974, St Helens became part of Merseyside County Fire Brigade.

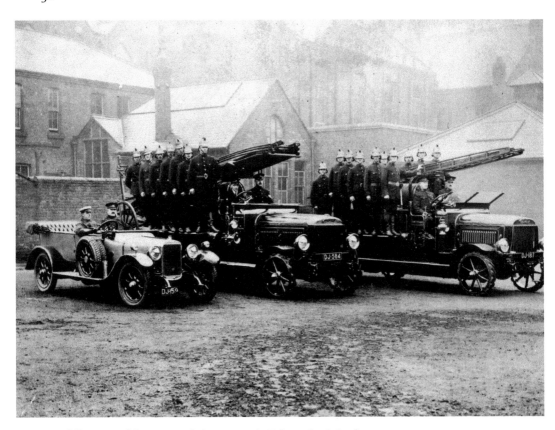

Two fully manned fire engines belonging to St Helens Fire Brigade, *c.* 1910.

4. Health and Education

Industrial growth brought overcrowding, pollution, illness and epidemics. The atmosphere was polluted by chemical fumes and coal smoke. Cholera broke out in 1849 and 1854; typhoid was also an unwelcome visitor to the town. St Helens industrialist Peter Greenall had requested a St Helens infirmary in the early 1840s, although this took many years to become a reality. In 1873, Dr Robert McNicoll was appointed the town's first medical officer. Despite the provision of hospitals, in his 1885 report for the Local Government Board John Spear said that 'the typhoid death rate between 1872 and 81 was three times the national average'.

DID YOU KNOW?
In 1845, at the Greenbank Slaughter House, cattle were killed in the open street. The offal was then heaped, and the blood left to run away.

St Helens Cottage Hospital opened in January 1873 when John Fenwick Allen, Sutton Copper Works manager, leased part of a house from Sutton landowner Michael Hughes. Andrew George Kurtz, owner of Kurtz Chemical Works, was a benefactor of the hospital, which had just nine beds. Each patient had to pay a shilling a day unless they had enrolled in their penny-a-week scheme. The first matron was Martha Walker, a Quaker who had worked in a hospital camp in the American Civil War. Three young orphans from Whiston Hospital, one aged seven and two aged eight, helped her. Martha was there until 1875.

By 1896 there were fifty beds and many extensions had taken place, leading to it becoming St Helens Hospital. By 1904 there were more than 100 beds, a new operating theatre, mortuary, laundry, kitchen, offices and staff accommodation.

The hospital continued to play an important part in the life and health of the town until it was replaced by the new £100 million hospital in 2008.

Rainhill Lunatic Asylum opened on 1 January 1851 as the third County Lunatic Asylum and had many names during its existence. It was known as Rainhill Hospital when it closed in 1991/92. It consisted of two sites. The Sherdley Division was the original building, designed by Harvey Lonsdale Elms; however, when Liverpool's asylums were closed tremendous pressure was put on these facilities and additional wings were added to the Sherdley site. In 1877 the Avon Division was added and was designed to accommodate long-term, chronically ill psychiatric patients. The two sections were connected by an

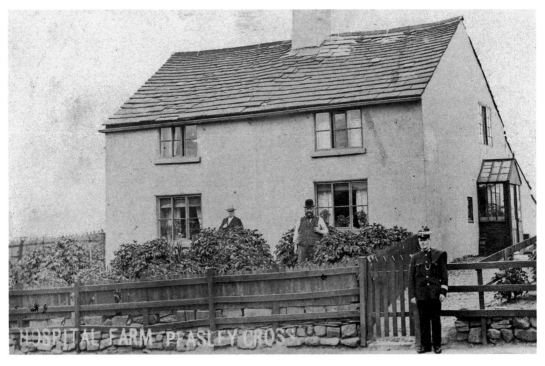

The Hospital Farm, Peasley Cross.

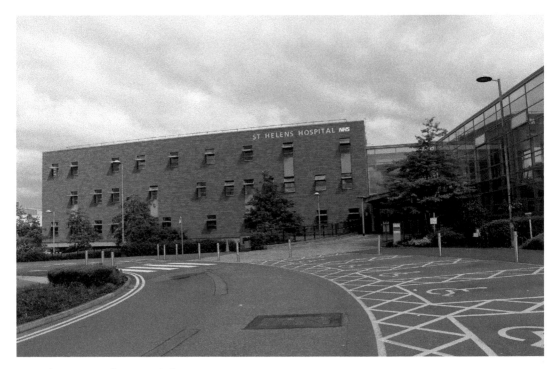

The new St Helens Hospital.

underground tunnel system constructed beneath Rainhill Road and accessible only to hospital staff.

During the First World War when it was overcrowded with 2,395 patients, 110 staff had been called up and eight were killed in action. In 1918 there were 498 deaths: 119 from TB and the rest from Spanish flu.

It became the largest and busiest hospital in Europe, holding around 3,000 residents at one stage. However, in the late twentieth century the government placed emphasis on care in the community, leading to the Avon Division closing in 1987 and the Sherdley Division closing in 1992. It is now Reeve Retirement Village and a housing development. Another part of Rainhill Hospital was the Scott Clinic, a medium secure unit named after the late Dr Peter Scott. One of its most notorious patients was Michael Abram, who stabbed former Beatle George Harrison multiple times. He was released on 4 July 2002.

Willowbrook Hospice is situated in Prescot and cares for people with life-limiting diseases living in St Helens, Knowsley and Prescot. In 1992–93 £1.8 million was raised, and in 1994 St Helens Council donated land on the Knowsley and St Helens boundary. On 11 January 1996 Lord Derby 'turned the first sod' and building started on the Portico Lane site. Princess Alexandra officially opened the hospice on 20 May 1999. In 2015, it was awarded the Queen's Award for Voluntary Services.

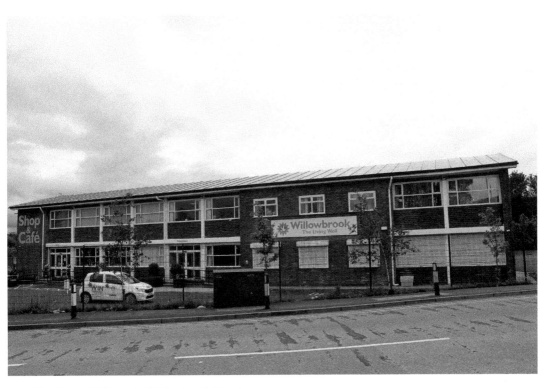

The Living Well, run by Willowbrook Hospice.

The first Providence 'hospital' was founded in George Street in 1882 when Mother Magdalen Taylor, who served in the Crimean War with Florence Nightingale, and four sisters from the Order of the Poor Servants of the Mother of God started nursing there.

In 1884, the Walmsey-Cotham family leased Hardshaw Hall, Tolver Street, to the sisters and it opened as a hospital on 15 September. In 1887, Lord Stanley laid the foundation stone for the first extension, while in 1888 Emily Garton bequeathed £40,000 to St Helens Infirmary, a portion of which went to the Providence Free Hospital.

In 1977, the sixteen-bed children's ward closed, and the proposed hospital closure was announced in 1979. Despite a campaign to keep the hospital open, which included support from local-born entertainer Bernie Clifton, who had lived opposite the hospital in Charles Street, its doors closed in 1982. Among the last sisters to leave were Sister Claire and Sister Ambrose.

Today the Providence Hospital site houses the headquarters of Arena Housing Association Ltd, but the original Hardshaw Hall still stands at the heart of the building.

An influenza epidemic struck at the beginning of 1951, with between 10,000 and 15,000 local people ill. It resulted in the closure of St Helens and Providence Hospitals as many of the staff were also ill. By the end of January, 270 had died from it.

St Helens has produced noted medical pioneers such as Dr Henry Ambrose Grundy Brooke, who discovered Brooke's Disease or Brooke's-Spiegler syndrome, a condition involving multiple skin tumours. He was born in St Helens in 1854, and the family left the

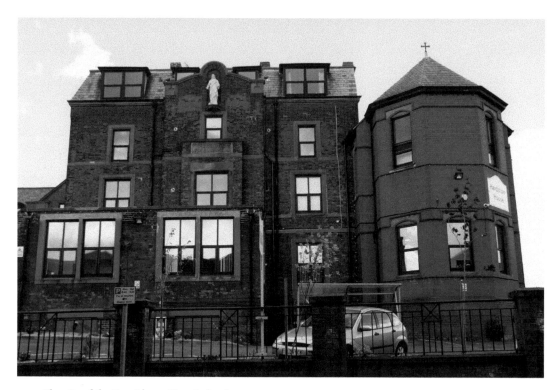

The site of the Providence Hospital today.

Bernie Clifton.

town in 1857. At sixteen he started his distinguished career by entering Owens College, Manchester, to study medicine. He trained at Guy's Hospital and then, after acquiring a BA, worked at the Royal College of Surgeons, London. After working abroad, he returned to Manchester and became a leading practitioner in the field of dermatology. He died in 1919.

The beginning of education for the sons of the 'poor men' lay in charity chapels. There were probably two in the townships: St Helens Chapel, Windle, founded by John Bold in 1330, and one at Windleshaw founded by Sir Thomas Gerard in 1415. When these were dissolved by Edward VI (r. 1547–53) the township was without educational provision. This was remedied in 1613 when a derelict chapel was handed over to nine trustees by owner Katherine Downbell to restore and provide education. The trustees were of mixed denominations, leading to a more comprehensive education.

DID YOU KNOW?
There was an additional problem at many of the factory schools. Many of the boys went to school straight from work, such as the 'Red Lads', who came straight from polishing benches. They made everything they touched – including forms and books – red too.

As the town expanded education lay with Sunday schools, and in 1833, 1,430 children were attending them. In 1834, Pigot's Lancashire Directory describes the educational provision as 'an endowed free school, a Catholic charity and several Sunday schools'.

It lists free schools at Moorflat, Duke Street (RC), Ravenhead and Eccleston. There were Boarding Schools for Ladies at Green End House, Sutton, and two more at Eccleston, along with a Gentlemen's Boarding School at Cowley Hill. These closed as the town's pollution grew. More schools were built in each of the four townships and on 8 June 1854 the foundation stone of the Wesleyan Day Schools was laid. The boys' school faced Waterloo Street and the girls' and infants', together with the schoolmaster's house, fronted Milk Street.

There was the Old Grammar School, Eccleston Hill, which opened in the 1820s. One headmaster was Thomas Seddon, father of Richard Seddon, who became Prime Minister of New Zealand. Moorflat Anglican school was opened in 1793 on the Moorflat near the workhouse. In the 1820s this school was educating forty children, and by 1833 it was eighty-two. It was described as 'one storied in grey stone, set back in the school yard behind a three-foot wall'.

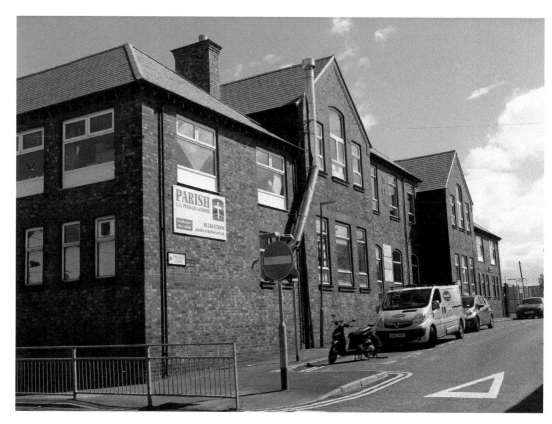

Parish Church of England Primary School.

Cowley School was founded by Sarah Cowley, who left a bequest in 1714 that was 'for the bringing up of poore persons children to the schools of St Elens'. The school dates to 1716. The trustees were also responsible for the building of the Cowley Schools, Cowley Hill Lane, which opened in 1882. This accommodated 150 boys and 100 girls. There were evening classes here until the Gamble Institute opened. By 1912 the girls had their own building while the boys moved to the new South Block next door. In 1930, girls also occupied this when the boys moved to Hard Lane. In 1965 the schools were known as Cowley Girls' School and Cowley Boys' Secondary Grammar School.

In 1970 the school became a co-educational comprehensive school and by 1978 it had become Cowley High School. In 2001 it gained Language Specialist status and became Cowley Language College. Since 2010 it has been known as Cowley International College.

Notre Dame School goes back to 3 May 1858, when the Sisters of Notre Dame of Namur started to provide education for young ladies at No. 10 Hardshaw Street, moving to North Road and then to the new site in Eccleston. In 1864 a boarding school was started and closed in 1920 because more spaces were needed for the day school, which became a direct grammar school after the Education Act. The foundation stone for the Eccleston site was laid on 20 September 1951. Present was Sister Marie of Trinity, who was killed

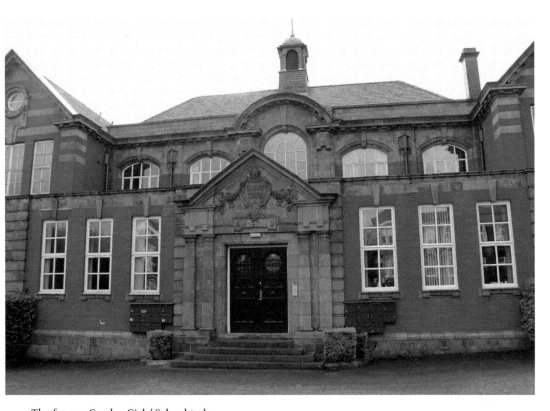

The former Cowley Girls' School today.

Cowley International College.

the following day in the London Euston train disaster. The school was completed in September 1954, having 630 places. In 1987 it merged with West Park Grammar School to become De la Salle comprehensive school.

West Park School was founded by the De la Salle teaching brothers Alphonse, Francis and Nilus, who came to St Helens from Rome. In 1899 they acquired a house in St George's Road with the aim of opening a secondary school for Catholic boys. In 1911 it opened its doors and by the following year it had 100 fee-paying pupils. In 1918 the school achieved recognition by the Board of Education when it was awarded six scholarships. A new school was officially opened in 1925 with facilities for 250 pupils. It moved to Alder Hey Road in 1965. Now a mixed comprehensive, De la Salle High School occupies the former Notre Dame premises at Mill Brow.

Grange Park Senior School was built 1938 as two single-sex schools that could accommodate 600 pupils. In 1953 it became Grange Park Technical School, one of the few technical schools in the country following the Butler Act of 1944. It became a co-educational school and later a comprehensive school. In 1991 the school joined with Rivington High School and became known as Broadway until 2006/7 when Broadway was taken over by Cowley School. It closed in 2009.

St Helens College has its origins in the Gamble Institute, Victoria Square, which today houses the Central Library. Sir David Gamble donated £30,000 (equivalent to £3.57 million

Grange Park School in the 1970s.

today) to set up a suitable educational facility. Sir David Gamble was also the first mayor of St Helens. He said, referring to the building of this Technical Institution, it is 'for the purpose of assisting our people to make themselves equal or superior to those countries where technical education has been an institution for a great number of years'.

It was completed in 1896 and opened on 5 November that year. It was responding to the need for employees with the technical qualifications required by local industries. The ground floor housed a library, including a ladies-only reading room. The basement was for manual training, and the first floor had technical classrooms, while the second floor had a third laboratory, chemical and arts departments.

In the late 1950s the institution spread from Water Street and after further growth it became a technical college in 1959 and merged with Newton College in 1986. This campus has now closed but the college has a second campus – the Technology Centre, Pocket Nook. In January 2008, the 1959 building was demolished, and the new £62 million college was completed in 2011.

St Helens has had many notable scientists, such as Robert Rodney Porter who was born in Newton-le-Willows on 8 October 1917. In 1972 he was awarded the Nobel Prize in Physiology or Medicine with his colleague Gerald Edelman for determining the chemical structure of an antibody. He died in 1985 in a road accident; however, his name lives on as the new Oxford Glycobiology Institute at Oxford University is called the Rodney Porter Building in his memory.

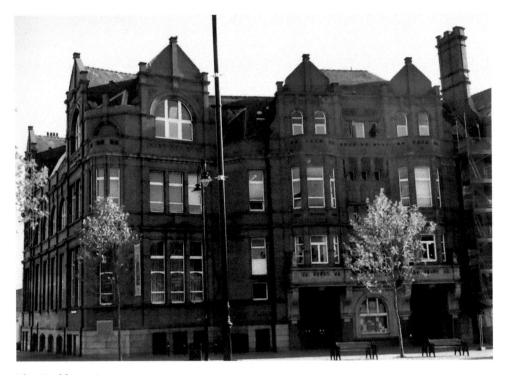

The Gamble Institute.

The new
St Helens College.

John William Draper was born in St Helens on 5 May 1811 but moved around England, no doubt because his father John was a Wesleyan minister. It is thought that Draper was responsible for the world's first photographic print, taken in 1839–40, and the first clear photograph of the moon, taken in 1840. John and his family emigrated to Mecklenburg,

United States, where he began his scientific research and had several papers published in 1834. The scientific term Draper point is named after him. He died in 1882 aged seventy.

> DID YOU KNOW?
> John William Draper's wife, Antonia Caetana de Paiva Pereira Gardner (c. 1814–70), was the daughter of Daniel Gardener, court physician to John IV of Portugal and Charlotte of Spain. She was born in Brazil after the royal family had fled Portugal because of Napoleon's invasion. Around 1830 she was sent with her brother Daniel to live with their aunt in London.

Harold D'acre Robinson Lowe was born on 1 February 1886 and lived at Robins Lane and Boundary Road. In 1905 the family emigrated to Canada. It was here that he embarked on a series of occupations before commencing his career, which involved fossil collecting at the aged of thirty-nine. He became a leading expert in this field and had the dinosaur Monoclines Lowei named after him. He died in 1952.

Hugh Stott Taylor was born in St Helens on 6 February 1890. He attended Lowe House Elementary School and then Cowley School. He then studied at Liverpool University where he gained a BSc in 1909 and an MSc in 1910. He emigrated to America where he taught at Princeton University and made a landmark contribution to catalytic theory in 1925. His contribution to the scientific world continued in the Second World War when he took a leading role in the chemical work connected to the development of the atomic bomb. In 1953 he was knighted by Elizabeth II and was made a Knight of the Order of St Gregory by Pope Pius XII. Hugh Scott Taylor died in 1974.

John Rylands was born in Parr on 7 February 1801. His father Joseph was a weaver and ran a draper's shop in Hardshaw. He was educated at Cowley School but at sixteen had already started his own handloom manufacturing business. It was so successful he was joined by his three older brothers and then his father to form Rylands & Sons. In 1823 the business moved to Manchester and by the early 1850s John Rylands was the largest textile merchant in Manchester; he was the first Lancastrian to become a millionaire. By 1860 he was regarded as the most successful merchant in the country and the success continued as in the 1870s branches were opened in Paris and Montreal with agencies worldwide.

After his death in 1888 his widow Enriqueta Augustina Tennant founded the world-renowned John Rylands Library, Manchester, a late Victorian, neo-Gothic building on Deansgate. It opened in 1900. There is also a memorial to him in the Southern Cemetery, Manchester.

Theodore Cardwell Barker was born in 1923 and was an influential figure in the field of urban history following the publication of *A Merseyside Town in the Industrial Revolution* in 1954. He died in 2001. John Raymond Harris, Barker's co-author, was also born in 1923. He died in 1997.

5. The Churches

Windleshaw Chantry was founded in 1435 by Sir Thomas Gerard of Bryn and here a priest would 'celebrate for the souls of the founders antecessors for ever'.

It is the oldest building of worship and oldest ruin in St Helens. Situated in a corner of St Helens Cemetery near the Abbey Road entrance, it was built of locally quarried sandstone and has a 36-foot-high tower. There are many interesting graves, including that of Jean de la Bruyere, who came from St Gobain in 1739 to manage Ravenhead glassworks. There is also the grave of three infants of the Orrell family who died of smallpox in 1782 and 1785. Following the Reformation it fell into decay, and in the early seventeenth century it became a Catholic burial ground. There is a story that officers in Oliver Cromwell's army enjoyed hospitality in the Windleshaw Abbey House, Dentons Green Lane, while some of their men were stripping the lead off the chantry roof to make bullets.

The Quaker House, sometimes known as the Friends Meeting House, is the town's oldest building. It was standing in 1597 when three plots of land were recorded as being sold by Sir Thomas Gerard of Bryn. The building and three land plots were later bought by Quaker George Shaw, a farmer and saddler from Bickerstaffe, in 1676. The Church Street

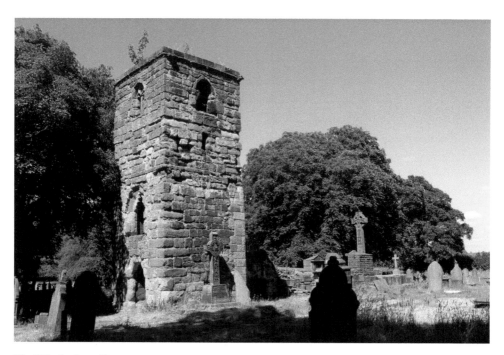

The Windleshaw Chantry.

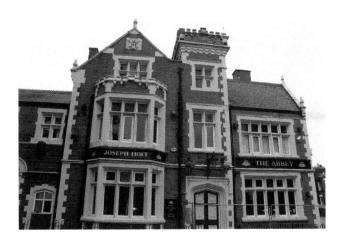

The current Abbey Pub, which opened in 1892.

DID YOU KNOW?
It was reported that in the 1880/90s drunkenness and social disorders were a perpetual problem. By 1883 it was recorded that there were 145 public houses and 150 beer sellers in the town. During that year 1,500 people were summoned or apprehended for drunkenness.

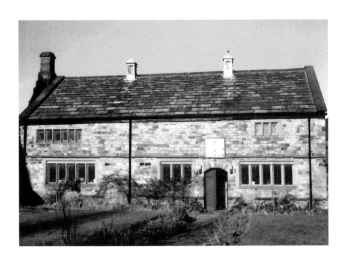

The Quaker House.

site opened as a place of worship in 1679 and has been a meeting place for Quakers ever since. Shaw Street, George Street and Bickerstaffe Street were all named after the man who founded the Friends Meeting House. The park in Shaw Street was once their burial ground and is now leased to St Helens for a peppercorn rent. Here there are still flat gravestones and an Ice Age stone, which was transported from Crab Street – another of George Shaw's land buys. The sundial over the door has the date '1753' inscribed upon it.

The Church of St Helen is also known as St Helens Parish Church and is on the site of the ancient chapel of St Elyn. At least four other buildings have stood on this Church Street site. There was the building that opened in 1618, and was repaired by the Downbells. There followed another structure from 1750 to 1780 with a tower added. This was extended in 1816 to cover the burial ground. Land to provide a new burial ground was bought to the south-east, which was removed in the early 1970s to make way for the building of St Mary's Market Complex. Following the extensions of 1816, the church became known as St Mary's. Improvements continued to be made to the church and in 1888 a new chancel was created, followed by electric lighting. However, on 2 December 1916 disaster struck when the roof caught fire and destroyed virtually the whole building. Work started on rebuilding the new parish church, and the foundation stone was laid on 17 June 1920 by the bishop of Liverpool. The new church was designed by W. D. Caroe and was opened on 7 November 1926. It was rededicated to St Helen. It is a designated Grade II listed building and falls within the diocese of Liverpool.

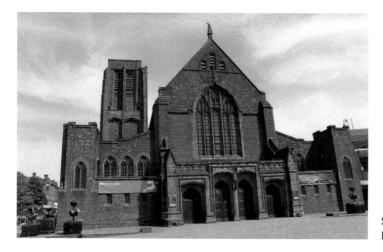

St Helens
Parish Church.

The Grotto
Lowe House.

In 1710, some parish church worshipers left and built their own Independent Chapel in Ormskirk Street, known as the Top Chapel and the Congregational Church. It was replaced by a larger building in 1826, which was enlarged in 1869 and 1883. It was demolished in the 1970s and the NatWest bank now stands on this site.

St Mary's Lowe House Church is named after Winefred Gorsuch Eccleston (née Lowe), who donated the land it stands on. Mrs Eccleston was the widow of John Gorsuch Eccleston of Eccleston Hall and in 1793 the old Lowe House Chapel was built on these 5 acres of her land at Crab Lane, now Crab Street. It was enlarged and had a tower built in 1857. The new Lowe House Church was the idea of Father Reginald Riley, who was the parish priest from 1912 to 1946. The building work started in 1924 and the foundation stone was laid by the Archbishop of Liverpool, Frederick William Keating, on 11 May 1924.

Designed by Charles B. Powell, an Irish architect, it was opened on 27 October 1929 and was called 'a poem in stone' at the opening. It is often referred to as the 'Basilica of St Helens' and 'the Poor Man's Cathedral', referring to the fact that the church was funded by local people who were struggling through tough economic times. Its tower is 130 feet tall and the dome is Renaissance in style. The copper cross that sits on top of the dome is 16 feet high and was donated to the church by the family of Mr James Yearsley, whose company had laid the building's foundations. It has a complete set of forty-seven carillon bells, which is the largest in the country. Carillon bells can be played in musical notation rather than in sequence by ropes.

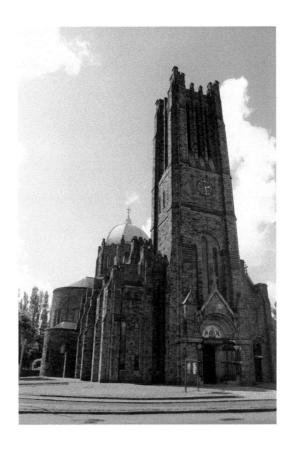

Lowe House Church.

Before the Wesleyan Chapel opened in Tontine Street in 1814 there were many Methodist meeting places. The first was the home of Joseph Harris, manager of Ravenhead Copper Works in 1780. His house was next to the Navigation Tavern, near Grove Street and John Wesley stayed here in 1782. A small chapel was built in Market Street and Dame Plumb's School, next to the Robin Hood Inn, Tontine Street was also a meeting place until the new chapel opened in 1814. This could seat 450 people and had its own graveyard. It was demolished around 1890.

A new chapel was built in Cotham Street (now Corporation Street) in 1869. This was demolished in the 1970s and replaced by Wesley House and a smaller Wesley Methodist Church in Vincent Street.

Wesley House.

The new
Wesleyan Church.

The original St Thomas Church was built in 1839 in Westfield Street by the Greenall family and some patrons were buried in the grounds. However, the main burial ground was in Hewitt Avenue, which opened in 1887. Burials stopped in 1960 and it closed in 1983.The church itself was rebuilt in 1910 but suffered a disastrous fire in 1960. This distinctive red-brick building is now restored and is a local landmark.

Holy Cross Church was built in Corporation Street 1861–62 and it is said that the stones came from Crank Caverns. It was built by the Society of Jesus and designed by Joseph John Scoles and is a Grade II listed building. The foundation stone was laid on 3 May 1860 and opened on 1 May 1862.

St Anne's Retreat, Sutton, was situated between Gerard's Lane and St Helens Railway and was designed by John Middlehurst. The site and building stone were donated to the Passionists by John Smith, a self-made railway engineer born in Windle in 1794 and who died in 1862 at St Anne's Villa, near St Helens Retreat. The Passionists built a Gothic church with a tower and steeple and next to it a monastery. There were thirty to forty Catholics in this area who had no church until St Anne's was completed in 1851.

St Thomas's Church,
Westfield Street.

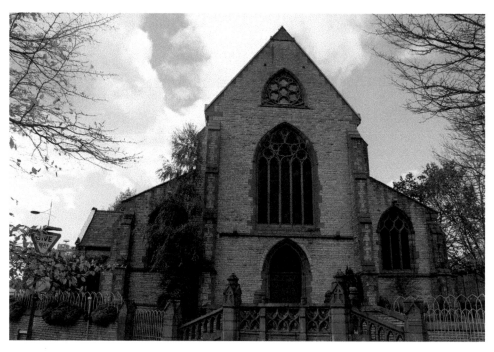

Holy Cross Church.

On 16 November 1855 the Holy Cross convent was opened in a cottage at Peckers Hill and inhabited by a community of Passionist Sisters, whose order had been founded four years before by Elizabeth Prout. They were here until 29 November 1901 when they moved to a new convent at Waterdale House, Waterdale Crescent and Gerards Lane.

This historical site is the home to three potential saints: Elizabeth Prout (1807–64); Dominic Barbei (1792–1849), an Italian farmer's son who was beatified in 1963 and chose the site for the original church; and Father Ignatius Spencer (1799–1864). Father Spencer had been born George Spencer on 21 December 1799 and is an ancestor of Winston Spencer Churchill and Diana, Princess of Wales. Princes William and Harry are his great-great-great-great nephews. In 2011 there was an inquiry into his possible sainthood.

In time mining subsidence led to the demolition of the convent's tower and eventually the whole building. Its replacement opened in 1973; however, the convent founded by Elizabeth Prout closed on 13 June 1979 and became a fun pub, initially called Cloisters and then the Tropical, before being demolished.

St Edmund Arrowsmith was born in Haydock, Lancashire, in 1585, son of Robert and Margery Arrowsmith (née Gerard). His birth name was Bryan, but he took the name Edmund at his confirmation. The family suffered for their Roman Catholic faith. His parents and the household where driven from their home and taken to Lancaster Castle. His maternal grandfather was a recusant and his other grandfather died a confessor in prison. While his parents languished in prison, Edmund and his three siblings were left to fend for themselves until neighbours took them in. As he grew up, he was put in the charge

of an elderly priest until at twenty he entered the English College, Douri, France. He was ordained in France in 1611, returning to England in 1613 and becoming a Jesuit in 1624.

In the summer of 1628, he was betrayed and after a tip-off fled to Brindle, Chorley and was captured at Brindle Moss and taken to the Boar's Head. On the following day he was taken to Lancaster Castle where he was tried for high treason and found guilty. On 28 August he was dragged through the city on a hurdle to the gallows on the moor. He was then hanged, drawn and quartered. After his execution a Catholic cut off one of his hands as a relic. This is preserved in a silver casket at St Oswald and St Edmund Arrowsmith Church, Ashton-in-Makerfield.

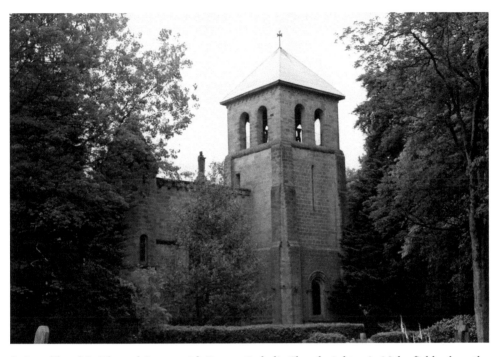

St Oswald and St Edmund Arrowsmith Roman Catholic Church, Ashton-in-Makerfield, where the hand of St Edmund Arrowsmith is preserved in a silver casket. After his execution a Catholic cut off one of his hands as a relic.

DID YOU KNOW?
During the First World War many priests served as army chaplains. One of these was Father Felix Hawarden who was wounded and gassed, and while he was on a hospital ship travelling to Egypt it was torpedoed. He had to cling to a plank for four hours before being rescued.

6. This Sporting Life

St Helens Rugby Football Club (Saints) was founded on 19 November 1873 at the Fleece Hotel, Church Street, by William Douglas Herman. It is one of the oldest members of the Rugby Football League and was originally called the St Helens Football Club. Its first match was on 31 January 1874 when the twenty-strong St Helens team lost to Liverpool Road Infirmary. They became the St Helens Rangers until the 1880s and moved from their City Road ground to Knowsley Road in 1890, where they won their first match against Manchester Rangers.

In 1895, having resigned from the Rugby Football Union, they became part of the newly formed Northern Union. They won their first new code match beating the Rochdale Hornets. Their playing strip was a vertically striped blue and white kit.

Rugby League was developing, and the Challenge Cup was created in 1897. St Helens had the honour of playing Batley in the first final, only to lose 10-3. From 1897 until 1901 they struggled to find success and even promotion to the combined Lancashire and Yorkshire combined Division One in 1902/03 was short-lived. They were soon relegated.

Another local team, St Helens Recs, with whom Saints had shared the City Road ground, were making their presence felt. Recs joined the Northern Union in 1913.

The First World War years proved difficult for the game and afterwards the Saints struggled to break through to the top. In the 1930s they won their first National Championship, but by the decade's end they had won no more accolades. The Second World War meant a full squad was impossible and they struggled to compete.

The new Saints Stadium.

The Steve Prescott Bridge, named after the St Helens Rugby League player who died in 2013.

The 1950s saw a change in fortunes, as in 1956 Saints beat Halifax to take the Challenge Cup. This was followed in the 1960s with more success and the introduction of the red vee kit in 1961. In the 1970s they reached three Challenge Cup finals and the 1980s saw a pattern of mixed fortunes emerging, ending in a Challenge Cup defeat in 1989. Since the inception of Super League, Saints have proved to be a very successful team, winning the title six times and Challenge Cup a further seven times.

St Helens Cardinals American Football Team was created by sixth formers from a local school who were boosted by players from the defunct Leigh Razorbacks. They won the UKAFL bowl game in 1987 and closed in 1998.

St Helens has produced and nurtured many world-class sportspeople; this section discusses just some of them. Geoff Duke OBE was born in Duke Street, St Helens, on 29 March 1923. He was educated at Cowley Prep and Grammar School and started with motorcycles as a youngster. During the Second World War he served in the Royal Signals, reaching the rank of sergeant; he was demobbed in 1947. In 1951 he achieved his first World Championship as a motorbike rider in the 500 cc and 350 cc events. In this year he became the Sportsman of the Year (forerunner to BBC Sports Personality of the Year). He achieved further World Championships in 1953, 1954 and 1955 – the first World Championship hat-trick. After retiring, he settled in the Isle of Man. He died in 2015, aged ninety-two.

Cricket was also another popular sport and here is the Cricket Pavilion, Newton-le-Willows, c. 1890.

Motorcyclist Geoff Duke in a race, c. 1950.

Dave 'Chizzy' Chisnall Lyon MBE was born in St Helens in 1962 and started his career with the Greenall St Helens Amateur Boxing Club. He competed in the Summer Olympics in 1984 and 1988 and won gold in the flyweight division at the 1986 Commonwealth Games, Edinburgh.

St Helens-born boxer Martin Murray fought for the World Championship four times and sadly was defeated on each occasion. He was born at Fingerpost on 27 September 1982 and went to Merton Bank Primary School, St Augustine's and Cowley High School. His first venture into the ring came when he was seven when he attended a taster session at St Helens Town Boxing Club, and he had his first amateur fight at the age of eleven. After winning several schoolboy titles, he won the ABA welterweight title in 2004. He turned professional in 2007 and after winning his first twenty-three fights he then went onto his first world middleweight title fight against Felix Strurm in 2011. His final challenge was in 2016.

Professional darts player Dave 'Chizzy' Chisnall was born on 12 September 1980. His career started with the BDO (British Darts Organisation) and he was runner-up in their World Championship in 2010. In 2011 he switched to the PDC (Professional Darts Corporation) and has won eleven Pro-Tour events and reached the final of the 2013 World Grand Prix.

Fellow darts player Michael 'Bullyboy' Smith was born in St Helens on 18 September 1990 and educated at St Cuthbert's High School and St Helens College. He achieved six titles on the DC Pro-Tour and was runner-up in the 2019 World Championship to Michael Van Gerwen. In 2018 Dave Chisnall was No. 8 and Michael Smith No. 9 in the PDC Order of Merit.

International footballer John Connelly (b. July 1939) began his playing career with St Helens Town before been spotted by a scout for Burnley Football Cub where he began playing in 1957. He played for Manchester United, Blackburn Rovers and Bury. His international debut was in 1959 and he played twenty games, scoring seven goals. In 1966 he played for England in the opening World Cup game against Uruguay but then was dropped from the team. He was one of four players who played in the tournament but not the final. The others were Jimmy Greaves, Terry Paine and Ian Callaghan. He died in 2012.

Bill Foulkes came from an illustrious sporting family. His grandfather William captained Saints in their first Rugby League Cup final, while his father James played for Saints and football for New Brighton. Bill was born on 5 January 1932 and was educated at Nutgrove School and Whiston Secondary School. He played for Manchester United in the 1950s and 1960s and was one of the Busby Babes – Sir Matt Busby's youthful team of this era. He scored nine goals in eighteen seasons. He survived the Munich air crash on 6 February 1958 in which twenty-three people died, including many teammates. The players were returning from a European Cup match and a decade later both he and Bobby Charlton were in the first English side to clinch the trophy. He died, aged eighty-one, on 25 November 2013.

Bert Trautman is probably most noted as the goalkeeper who played part of the 1956 FA Cup final with a broken neck. Although Bert was born in Germany in 1923, after serving in the Luftwaffe as a paratrooper and receiving the Iron Cross, he found himself at a prisoner-of-war camp in Ashton-in-Makerfield. When released in 1948, he stayed in Lancashire and became goalkeeper for St Helens Town. Club secretary Jack Friar took him under his wing and Trautman married his daughter Margaret. Trautman signed for Manchester City in 1949. He died in 2013.

Champion runner Bill McMinnis was born in 1915. He lived in Bronte Street and was educated at Rivington Road School, leaving at fourteen. He worked in the family's window-cleaning business and at night would run at Ruskin Drive. In 1936 he joined Sutton Harriers, the town's leading athletic club, where he soon made the first team. During the war he served in the RAF and was to remain enlisted as a physical training instructor after the war. He returned to Sutton and helped the team to win the National Cross-Country Championships in 1947, 1949, 1950 and 1951. His individual successes were to culminate in representing England in cross-country in 1953. In the 1950s he moved into marathon running and won the Liverpool Marathon in 1951 and Northern Counties Marathon in record time in 1953. He was the president of the St Helens-Sutton Athletics Club until his death in 2013.

DID YOU KNOW?
In 1998 former boxer Gary Stretch was the British Light Middleweight champion. He won twenty-three out of his twenty-five professional fights. He is now a successful actor with thirty-nine credits to his name, including Oliver Stone's *Alexander*. He lost out to Daniel Craig for the role of James Bond.

Lily Parr was born in 1905 in a rented house in Union Street. She was one of seven children born to George Parr, glass labourer, and Sarah, his wife. She played for the most successful women's football team of the time: the Dick, Kerr Ladies.

She started playing football with her brothers and, aged fourteen, joined the prestigious Dick, Kerr's team, which mainly consisted of workers from their Preston factory. While playing for this team she lodged with teammate Alice Norris, also from St Helens. In her first season she scored forty-three goals, and more than 900 goals in her career. She was a 5-foot-10-inch-tall winger who liked smoking Woodbines. During the First Word War interest in woman's football grew and continued afterwards, as illustrated by the attendance of 53,000 spectators at a 1920 Goodison Park match. The ladies' teams played against male teams as well, and Lily played in the first women's international football tournament between England and France in London in 1920. The team also toured France and the United States. In later life Parr trained as a nurse and worked in Whittingham Mental Hospital until retirement. She died in 1978 and is buried in St Helens.

Rachael Letsche, who was born in Sutton Leach in 1991, became world champion in the women's individual tumbling final in Daytona in 2014. Rachael attended Willow Tree Primary School and Sutton High where she began her tumbling career. In 2005 she represented Great Britain in Holland, and in November became the British Tumbling Champion in the fourteen- to fifteen-year age group. She took many international titles culminating in her gold medal success at Daytona. Rachael has retired but became the first tumbler to be inducted into the Gymnasts Hall of Fame in January 2019.

Haydock Park Racecourse has its origins in the grand racecourse at Newton Common, which even had its own railway station. Racing took place here from at least 1678 until it moved to the Haydock Park site in 1899. The celebrated Old Newton Cup Race keeps this legacy alive today.

The site of Haydock Park was originally owned by the Lancastrian Legh family who on elevation took the name Newton. Today it is owned and operated by the Jockey Club and hosts some of the most popular events such as the Grand National Trials in February.

It hosts pop concerts with artists such as Simply Red, Tom Jones and Rick Astley, who is from Newton-le-Willows.

DID YOU KNOW?
In the 1990s Haydock Park Racecourse was the venue for Noel Edmonds' Mr Blobby Crinkley Bottom Day, which was televised for the BBC.

7. Entertainment and Leisure

In 1886 the local paper, *St Helens Intelligencer*, stated many illnesses and a quarter of fatalities in the town were due to chest complaints thought to be caused by pollution. There was a need for areas where residents could go, breathe fresher air and relax in their limited leisure time. From 1850 onwards, Parliamentary committees encouraged the use of land for leisure and these were to be purchased at public expense.

> DID YOU KNOW?
> Originally a park meant an enclosure containing animals for hunting. They were once either part of the king's hunting forest or the grounds of royal palaces and landed gentry.

Thatto Heath Park was the town's first park and opened in 1884. However, before then there was a Victoria Gardens in the area that had been opened in the 1840s by Charles Whittle, landlord of the Engine Inn. He decided to create Oriental gardens on his wild land in front of the pub. This became a middle-class attraction and hosted dancing, singing and dining events and had its own resident band. A large dining room was built

Thatto Heath Park.

and among its patrons were the Liverpool Masonic Lodge. When Charles Whittle died in 1875 the park went to new owners, but by the 1890s it had disappeared. It was replaced by housing, but its legacy carries on through the name Whittle Street.

Victoria Park runs along City Road, Bishop Road, Cowley Hill Lane and Rutland Street and consists of 14 hectares of land. In the centre of the park is the Mansion House which, together with the surrounding land, was bought by St Helens Corporation in 1886 for £11,000 and became Cowley Hill Park. In 1887, to celebrate the Golden Jubilee of Queen Victoria, the park was renamed Victoria Park. In 1899 a Meteorological Station was built here by Boulton and Paul Ltd, and tennis courts were built in 1911. During the First World War Belgian refugees were housed in the Mansion House and allotments were laid out in the grounds. In the Second World War the iron railings were removed for munitions and replaced by hedges and much of the park was given to food cultivation and allotments.

In 1892 the Mansion House became the town's first Art Gallery and Museum; it closed in 1966. In 1974 the building became the headquarters of the council's then Parks Management Department until Age Concern (now Age UK) bought it in 1994.

Royalty visited here on 8 July 1913 when George V and Queen Mary passed through the park, and in the 1930s Edward, Prince of Wales (Edward VIII) came here.

In 2000, the play area was refurbished and a ball court, skate park and teen area were created. Another milestone came in 2005 when the Friends of Victoria Park (FOVP) was formed to campaign and support the park's restoration. In 2009 a Heritage Lottery Grant was applied for and received, resulting in a park renovation.

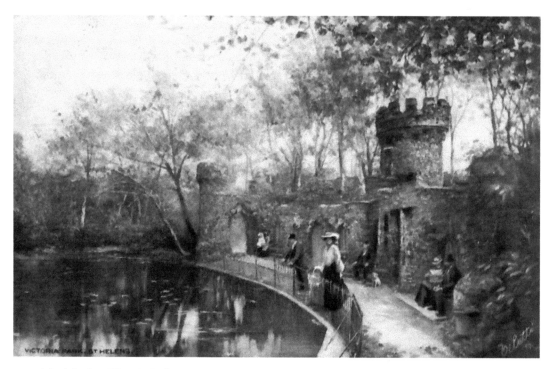

A look back at Victoria Park.

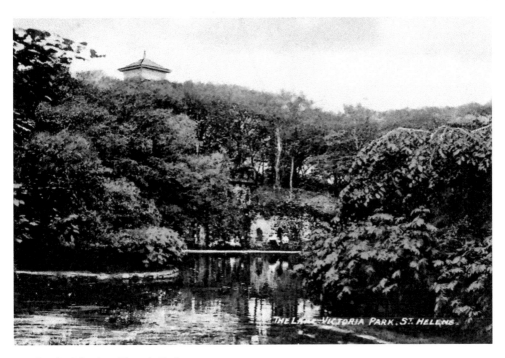

Another look back at Victoria Park.

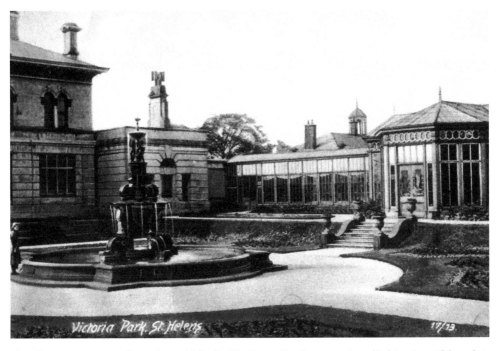

This famous terracotta fountain, paid for by Sir Henry Doulton, was installed in 1897. Although it no longer flows, it can still be seen today.

Victoria Park today.

DID YOU KNOW?
In 1838–39 a pavilion for 'aged and infirm men' was erected next to the bowls house
in Victoria Park.

In 1940 an air-raid shelter was built in Victoria Park with the capacity to hold 622
residents. It was decommissioned in December 1946 and is hidden under the grass mound
between St Mark's Lodge and the Mansion House.

Samuel Taylor VIII, a wealthy landowner, gave the parkland surrounding his estate,
including the water, to the townsfolk for their recreation. Taylor Park was opened on
18 May 1893 by the mayor, Mr A. Sinclair, in the presence of Samuel Taylor. There were
dams within the park – Big Dam, Little Dam and Corporation Dam – and the park has
included walks, fishing, boating lakes, formal gardens, woodlands and a small menagerie.

The Friends of Taylor Park were formed in 2002 and their initial aim was to
'improve the quality of the park and to ensure a safe and pleasant environment for
the benefit of residents'.

One thing that Victoria and Taylor Parks have in common is a Victorian milepost, both
of which were originally installed in the town centre. Victoria Park's sat on the Liverpool

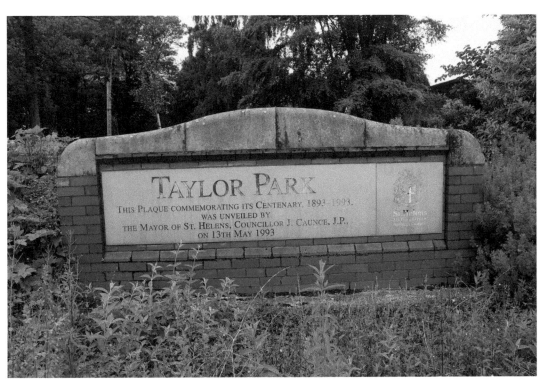

The dedication stone at Taylor Park.

The boathouse at Taylor Park today.

The Victorian milepost at
Victoria Park.

to Ashton-in-Makerfield turnpike road, which is now the A57, in the early 1800s. The Taylor Park one was on the same turnpike in Eccleston. They became gateposts on a house called The Gables in Balker Drive. The house belonged to Mr Charles Bishop, owner of Bishop Glass Works, who died in the 1920s.

The property came into the possession of the NHS and, following its demolition, the mileposts were rescued and placed in the parks.

DID YOU KNOW?
The first prosecution for illegal fishing in a public park took place in 1893. The defendant was a young man called Barnes who was accused of fishing in the Leg-of-Mutton-Dam, Taylor Park. He was prosecuted at the local police court before Messrs W. Tyrer and B. A. Dromgole. The case was dismissed.

Sherdley Park covers 336 acres of parkland and is named after the Sherdley family, who can be traced back to 1303 when they owned Sherdley Hall, orchard and gardens. Sherdley Old Hall was built in 1671 and later became Sherdley Hall Farm, which today is a Grade II listed building. In 1800 a colliery engine was installed close to Sutton Lodge, home of estate owner Michael Hughes, manager of Ravenhead Copper Works. Suffering from near suffocation because of the fumes, in 1805–06 he built a new mansion in the centre of Sherdley Park, which was demolished in 1949.

The park has a large dam, a small round wood, Sutton Hall Wood and Delph Wood. In 1953 the formal gardens were opened to the public. Sherdley Park was the home of the St Helens Show, which started life as a centenary festival in 1968 to celebrate 100 years since the town became a borough. It proved so popular that this three-day event grew to become Europe's largest free show. Among the acts who played here at the beginning of their careers were Beautiful South and Take That. The more established acts included Showaddywaddy and American singer Edwin Starr. In 2007 it was reinvented as the two-day St Helens Festival, but this no longer takes place.

Carr Mill Dam on the A571 (Carr Mill Road) is one of the country's largest bodies of inland water. Dating to the 1750s, it was originally a millpond, powering Carr's Mill, a corn mill that was here in the nineteenth century. 'Carr' comes from Norse, meaning 'marsh' or 'fen' and was not the name of the people who owned the mill. The land belonged to the Gerard family.

It was a popular area for families and at one time boasted its own 'Happy Valley'. It has an ancient woodland running by the railway as well as lakeside trails with the chance to see herons, great crested grebes and even kingfishers. Today Carr's Mill hosts competitive powerboat racing competitions and angling events.

Sherdley Park, the scene of the St Helens Show.

Carr Mill Dam.

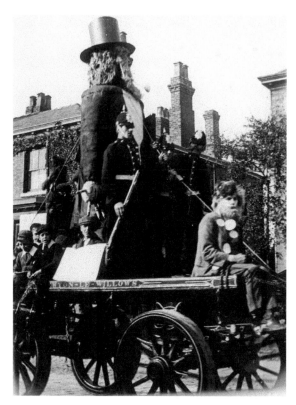

Another popular social and community event were Walking Days. This picture is of the May Carnival in High Street, Newton-le-Willows, c. 1910, and shows the local Militia float celebrating the Boer War with an effigy of Paul Kruger.

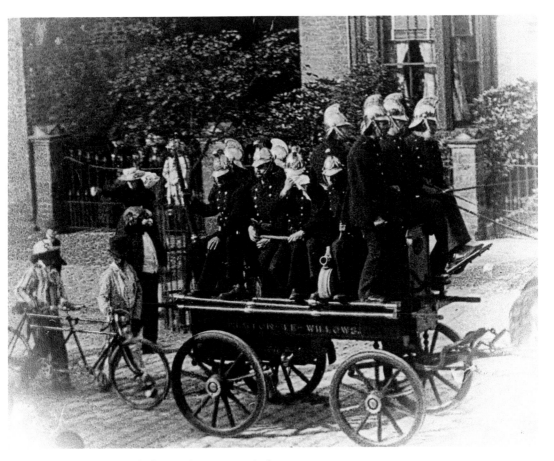

This is the Fire Brigade float at the same carnival, *c.* 1910.

As St Helens grew so did the need for entertainment, and this led to a wealth of theatres, music halls and cinemas. One of the most enduring is the Theatre Royal. The original building was in Bridge Street where the Running Horses is today. It was a wooden building and opened in 1847, but it was closed after the building was deemed to be a fire hazard. There are also stories of the roof collapsing under the weight of winter snow.

In 1861 the theatre moved to the corner of Milk Street and Waterloo Street, which became the site of the Citadel Arts Centre. It was opposite a school and was surrounded by terraced Victorian Houses. The first performance here was *The Gypsy King* on 26 April 1862 and among the great names to appear here was Vesta Tilly, star of their first pantomime, *The Babes in the Wood*, which opened on Boxing Day 1884. It is one of the great survivors of the golden age of British music hall. One manager was Wallace Revill, who bought land in Corporation Street where the current Theatre Royal stands. A new theatre designed by the renowned theatre architect Frank Matcham opened on 4 August 1890. It was destroyed by fire on the morning of Friday 13 October 1899, but it eventually reopened thanks to local businessmen who bought the site from Revill's trustees. Frank Matcham was again the architect and the new theatre opened on 20 May 1901.

On 4 July 1945 the roof collapsed, causing two fatalities and injuring twenty-six other people. The show that evening was *Wuthering Heights* and the orchestra had just struck up the overture. It is thought the collapse was a result of damage initially caused in September 1940 when a German bomb was dropped on Charles Street. The theatre continued until the 1950s when the advent of cinema and television took its toll on theatre audiences.

After some years as a neglected, shuttered building it was purchased by Pilkington Brothers and rebuilt in 1964 with a glass frontage, spacious foyer and one balcony. The grand opening was on 10 March 1964 with a programme that included a live broadcast by the BBC Northern Orchestra, Miss Joyce Grenfell and Mr Kenneth Horne. During this broadcast Prince Edward, the Queen's youngest son, was born. The theatre continued to host national stars and local amateur productions until the mid-1980s when Pilkington Brothers gifted the theatre to the then Merseyside County Council in 1986. In the mid-1980s the Theatre Royal (St Helens) Trust was established to operate the theatre for the benefit of the town.

The Friends of the Theatre Royal (St Helens Trust) was also formed to fundraise for the theatre. Among the stars who have appeared here are Bucks Fizz, Suzi Quatro, Shakin' Stevens, Ken Dodd, Tony Christie, Simon Ward and, of course, Sooty.

The Theatre Royal.

Another bastion of live theatre was the Hippodrome Theatre, which still stands today on the corner of Corporation Street and Shaw Street – now a bingo hall. It has also been known as the new Hippodrome Cinema.

It started as a music hall venue called the Peoples' Palace, which opened on 3 April 1893 and could hold 2,000 people. It was a wooden and corrugated-iron structure, which proved a stumbling block for when they applied for a Music Hall Licence there were objections by Wallace Revill because it was not a brick and stone fireproof building. Despite the refusal they opened anyway, and the large audience included the two magistrates who had earlier refused the licence. George Formby Sr made his stage debut here for 25s a week, while Vesta Tilly received £30 a week for performing here.

DID YOU KNOW?
In November 1906 Charlie Chaplin appeared at the Hippodrome in *Casey's Court.*

The music hall was renamed the Empire Theatre of Varieties, which opened on 1 June 1903. It was later sold to Thomas Barrasford, adding to his theatre chain of theatres, and was renamed the Hippodrome.

As cinema emerged the Hippodrome Theatre closed in 1937, reopening as the Hippodrome Cinema on 8 August 1938 with the screening of *Victoria the Great.* When the Hippodrome Theatre closed its doors on 31 August 1963 it reopened as a bingo hall, which still exists, the following day.

The Hippodrome today.

The Citadel Arts Theatre, Waterloo Street, was the second Theatre Royal from 1861 to 1890. It was one of the great survivors of the golden age of British music hall. When the theatre moved to Corporation Street the Citadel was bought by the St Helens Salvation Army who, it is believed, didn't want another music hall opening its doors here. During this time there was a complete rebuild, resulting in the loss of the second balcony and four private boxes.

The Citadel
Arts Theatre.

The Salvation Army moved to Salisbury House in the 1980s. The Citadel was then bought by the Rainford Trust, a charity established by the Pilkington family 'to provide a focus for art activities in the Borough of St Helens and in response to the needs of young people'. It was opened in 1988 by Richard Luce MP, the then Minister for Art, and has since played host to some of the greatest names in entertainment. The Citadel closed in 2019.

Films were another source of entertainment, but originally these were only two to three minutes long and shown in music halls between acts. In 1907 the Weisker brothers showed films in the Co-op Hall, Helena House, Baldwin Street, which was very popular during the silent film era. In 1910 the Town Hall and YMCA started screening films, but this ceased in 1915. The Hippodrome showed short films from 1903 onwards, eventually becoming a cinema. The first cinemas opened in 1911 and included the Scala Cinema, Ormskirk Street, built on the former Menzies Smithy and Veterinary Infirmary. It was originally the Electric Theatre at No. 35 Ormskirk Street, but was nicknamed 'Griffin's' after the owner Alfred Griffin, who also owned a furnishers and photographers at Nos 31 and 33 Ormskirk Street. Today this is the HSBC bank. The first purpose-built cinema was sold in 1928, with the new owners calling it The Scala. It closed in 1957 and the building was demolished. Today it is an Iceland supermarket with the Scala Snooker Club on the first floor – it retains the Scala name.

Another early cinema was the Parrvillion, Jackson Street, which was the first to adapt to sound. The Parrvillion closed in 1958, with the last screened film being *The End of an Affair*. It became Free's Glass Company. The Oxford Picturedrome, Duke Street, opened in 1912 with 800 seats. In the 1930s it was fitted with a British Talking Pictures sound system and renamed the Oxford Picture House. It closed in the mid-1950s and later became the Plaza Theatre Club. It has also been known as Cindy's, Lowie's, the Orange House and Larkins' Restaurant. It now houses shops and a pharmacy. The Beatles once played here. The Empire, Sutton ('Sutton Bug') was often referred to as 'Glover's Cinema' after the lessee R. Glover. All the seats were red and cost 1 penny apart from three blue rows at the rear, which cost 2 pennies. It closed in 1957.

Other cinemas were the Palladium, Boundary Road; Empire, Thatto Heath; Rivoli, Corporation Street; Beehive, Bridge Street; Savoy Cinema, Bridge Street; Capitol, corner of North Road; Electraceum, Haydock; Picturedrome, Haydock; Hippodrome, Earlestown; Empire, Earlestown; the Curzon, situated opposite Earlestown railway station; Pavilion Picturedrome, Earlestown; the Empire Cinema, Billinge, known as 'The Trock'.

The town today is served by Cineworld, which opened in March 2001 and has eleven screens. Lucem House Community Cinema Plus was founded in 2015 by the film society Take2Films as a community cinema to show independent films not shown at mainstream cinemas, or films that only had a short run.

The Millennium Centre, the site of the former Rivoli Cinema.

Lucem House Community Cinema Plus is in the former Unitarian Church, Corporation Street.

Inside Lucem House.

DID YOU KNOW?
In January 1976, screenings of *Jaws* at the ABC Cinema broke all existing box office records. In the first four days alone 11,000 had seen the film.

The town's growth in the industrial years led to an increase in the number of pubs. However, the town did already have some pubs, the first being the Old King's Head, which was built by Thomas Martindale in 1629 and tenanted as an inn in 1632. It was near St Helens Chapel. A new King's Head was built in Kirkland Street.

The Red Lion opened in 1730 at the end of Chapel Lane. The Black Bull followed in 1757 and then the Raven and Royal Hotel. It had become the Royal Raven by 1906, taking its name from the fact the Duke of Connaught had stayed overnight during his travel through the town with his troops.

The Fleece, which was a posting house, and the White Horse opened next, followed by the Sefton Arms. In 1846 they supplied refreshments to the late Emperor Napoleon III when he was Prince Napoleon. He was the guest of Sir John Gerard, Bart of Garswood, and they were returning from a hunting expedition at Windle.

Other pubs from this era were the Running Horses, Bridge Street, and Windleshaw Abbey House.

The improvements in roads also lead to coaching inns and hotels in the town and on the roads. The Bird I' Hand existed before 1808 when Peter Leyland was the landlord. It was demolished in 1937 and replaced by the building that still stands today.

DID YOU KNOW?
In 1887 Bridge Street had fourteen pubs, some next door to each other. These were the Black Bull, Bee Hive, Volunteer, White Horse, Adelphi, Nelson, Cock & Trumpet, Black Horse, Queens, Red Lion, Crooked Billet, Shakespeare, Old Time at Home and the A1.

The Legh Arms, Newton-le-Willows, c. 1900. It was built by Thomas Stone in 1845 and the first landlord was Thomas Prescott.

8. St Helens At War

One of the earliest notes about what is now St Helens is of a fort at Newton-le-Willows, which is on the Warrington to Wigan Roman road. There is dispute over the death of King Oswald of Northumbria as some sources record his *c*. AD 642 death in battle in at Oswestry, while others say he died at Winwick, near Newton-le-Willows. However, here there is a St Oswald's Well, a medieval structure that is associated with Oswald and his death.

Redbank was the site of the Civil War battle between Royalists under the command of the Duke of Hamilton and Oliver Cromwell's Parliamentarians in August 1648. Cromwell's forces are thought to have killed 1,000 men and taken 2,000 captives. The name Redbank comes from the amount of blood thought to have been spilt there.

The First World War

St Helens Pals has its roots in the South Lancashire Regiment (Prince of Wales's Volunteers), which was formed in 1881. It consisted of two battalions: the first formed from the former 40th Regiment of Foot and the second from the former 82nd Regiment of Foot. When war broke out in 1914 there were 2,000 men in the Territorial Force and around 600 reservists in the town. They were called up on 3 August and sent for training. St Helens was affected by Lord Kitchener's recruitment drive and the well-known poster carrying the slogan 'Your Country Needs You'.

The first week in August saw 8,000 men enlist, the second week 43,000, followed by 50,000 in the third week and 63,000 in the last. The tremendous response paved the way for the St Helens Battalion with the South Lancashire Regiment, which would be known as the St Helens Pals.

Following a recruitment meeting held at the Theatre Royal by Lord Derby and the mayor, Sir David Gamble, more than a thousand men volunteered for the St Helens Pals. Some could not be taken due to age, ill health or employment in a reserved occupation such as mining.

On 10 August the 5th Battalion of the South Lancashire Regiment was offered the choice of duty at home or active service overseas. They voted for overseas service and after training they found themselves in France in February 1915. This was the start of their presence in many major battles and the Pals suffered great losses, along with other regiments containing St Helens men involved in the conflict.

Four soldiers living in St Helens were awarded the Victoria Cross during the First World War. John Thomas Davies, known as Jack, was born at Rock Ferry, Birkenhead, on 29 September 1895, but moved to St Helens when he was young. He was eighteen when the First World War broke out and volunteered for service, joining the St Helens Pals. He went to France in 1915 and was wounded twice during the Battle of the Somme in 1916

but returned to duty each time. In 1918, Corporal Davies was caught up in fighting near Eppeville in northern France on 21 March. Three days later the battalion was in danger of being outflanked on both sides and was ordered to withdraw. John was aware this would have to be done via a barbed wire lined stream and, concerned the men would be mown down, launched a rear-guard action to keep the enemy at bay.

He mounted a parapet with his gun and created time for his colleagues to escape. It was presumed he had been killed in this action and his parents, now at Peasley Cross, were told of his death. His VC was awarded 'posthumously' before it was discovered he was still a prisoner of war. It is thought he was the only soldier to be awarded a posthumous VC while still alive. He was twenty-two at the time.

After the war he returned to St Helens and married Beatrice, his childhood sweetheart, and had three children. Sadly, in 1943 their son Alan drowned after an accident on ice in Taylor Park Lake. John died in 1955, aged sixty, and is buried at St Helens Cemetery. In 2018 a paving stone in Victoria Square was unveiled in his honour.

John Molyneux was born at No. 3 Marshall's Cross Road on 22 November 1890 and was educated at Holy Trinity Church of England School and then joined his father at the colliery. He enlisted as a private on 7 September 1914 and in 1915 he joined the 2nd Battalion, which became involved in the Gallipoli campaign. He was slightly wounded, but during the winter he was transferred out, suffering from frostbite.

He rejoined his regiment, travelling to France in 1916 and was engaged at the Somme where he was wounded. He returned to Britain, but in 1917 he was posted to the Ypres Salient where on 9 October 1917 he found himself under attack at Langemark. He organised a bombing party to clear the trench in front of a house where many enemies were killed and a machine gun was captured. His decoration was given by George V on 12 December 1917 and he also received the Belgian Croix de Guerre in February 1918. He was twenty-six when he won the VC. He married Mary Agnes Lyne and had a son and a daughter.

After the war he returned to the colliery and then worked at Pilkington Brothers Ltd until he retired. During the Second World War he served as a warrant officer in the West Lancashire Home Guard. He died aged eighty-one and was cremated, with his ashes being scattered in the Garden of Remembrance at St Helens Crematorium.

In July 2017 St Helens Council named a new street in Sutton John Molyneux VC Close, and later that year a commemorative paving stone was laid next to the St Helens cenotaph, marking the centenary of the presentation of his VC.

Norman Harvey was born on 6 April 1899 at Bull Cottages, Newton-le-Willows. He was fifteen when the war began and although underage managed to enlist in the 4th Battalion, South Lancashire Regiment, in November 1914. He was sent to France where he was twice wounded and returned home. While recuperating, his true age was discovered so he stayed in England for training. When he was nineteen, the required age for overseas service, he was transferred to the 1st Battalion, Royal Inniskilling Fusiliers, and sent to Belgium.

Norman was at Ingoyhem, near the French border, when his battalion were pinned down by enemy machine gun fire in a farmhouse, suffering many casualties. Norman's

commanding officer said: 'Norman charged at the enemy single handily going around to the left side of the farm.'

When Norman re-emerged he had killed two men, wounded one and captured twelve men and two guns. Later that day he charged another enemy post where a machine gun was concealed; the enemy fled. After darkness Norman went out on a reconnaissance mission and gathered significant information, even though he had a sprained ankle.

He received his VC from George V at Buckingham Palace on 15 May 1919. He returned home to Newton-le-Willows and worked on the railways. He married Nora Osmond and had two daughters and a son.

Aged forty, Norman enlisted to fight in the Second World War and joined the Royal Engineers as a sergeant. After promotion he was sent to Palestine where he died from a single rifle shot on 16 February 1942. He is buried in the Khayat Beach War Cemetery, Haifa, Israel. There is a street named after him in Newton-le-Willows. On 27 October 2018 a 2-metre-high statue of Norman Harvey was unveiled in Mesnes Park, Newton-le-Willows.

Frederick William Hall was born on 21 February 1885 in Kilkenny, Ireland, but was living at No. 81 Ormskirk Street, St Helens, from the age of six. His father was bombardier Frederick Hall, and young Frederick had four brothers and two sisters. The family later moved to No. 56 Dentons Green Lane. Shortly before his sixteenth birthday in 1901, he joined the Royal Scottish Rifles. He became a sergeant, but in 1913 he was discharged to join his mother and at least three of his brothers who had emigrated to Canada following his father's death in 1905. He worked as a clerk in Winnipeg where the family lived.

When war broke out, he joined the Winnipeg Light Infantry but then transferred to the Winnipeg Rifles. After training in England, the regiment went to Ypres, Belgium, and by 23 April 1915 they were just 1,500 yards behind enemy lines defending the position there. On 24 April when the commanding officer was killed Frederick took command, guiding the platoon to the front line where they took position under severe fire.

Frederick and two other soldiers, Corporal Payne and Private Rogerson, went back to rescue wounded soldiers. After successfully rescuing two, they attempted to rescue a third, but Frederick's two colleagues were wounded in the attempt. Frederick made a third attempt but, after hauling the man on his soldier, he was shot dead. The wounded man also died later.

His award of the VC was announced on 22 June 1915 and presented to his mother in August 1915. He was thirty and his body was never found. He is one of the missing commemorated on the Menin Gate Memorial. He was the first St Helens recipient of a VC, and a commemorative paving stone was laid at the St Helens cenotaph on 22 April 2015.

Dr Archibald McLaren Ferrie MC was awarded the Military Cross for 'conspicuous gallantry and devotion to duty' on 18 February 1918. Although born in Hamilton, Lanarkshire, in 1863, he came here in 1920. Between 1925 and 1930 his doctor's practice, Reid and Ferrie, was established at No. 2 Cotham Street. He was later to live at Fernlea, Dentons Green Lane. He worked at St Helens Hospital and the Providence Hospital and was a police surgeon and factory doctor.

During the Second World War he was a special reserve in the Army Medical Corps, but was not called up. He was medical officer to the Poison Gas Factory at Sutton and a member of the Imperial Chemical War Committee. He died on 2 January 1992 and in 1995 St Helens Hospital named the outpatients unit Ferrie Ward.

DID YOU KNOW?
The upper age limit for enlisting in the First World War was thirty-eight, but that didn't stop William Hudson from Atherton Street enlisting and giving his age as thirty-six. He was discharged as being medically unfit. His real age was fifty-three.

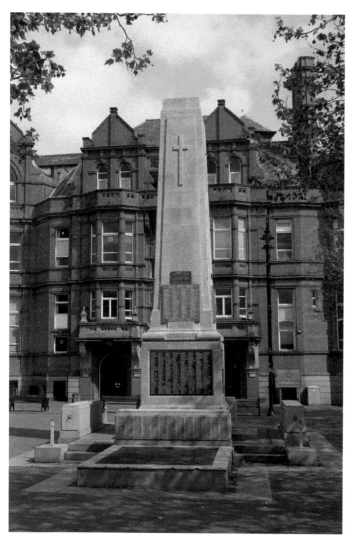

The cenotaph.

St Helens war memorial was erected in 1926 and was funded by a public subscription of £2,000. There were originally 2,270 names on it, but 469 names were added to commemorate those who fell during the Second World War. It was designed by Biram and Fletcher and made by William Rigby & Sons. It was unveiled on Easter Sunday, 4 April, the same year. Mrs Elizabeth Davies of Chancery Lane unveiled the memorial; she had lost five of her seven sons in the conflict. The central obelisk is made from Portland stone on a square dais, with a granite pedestal in each corner. On the front face is the inscription 'Our Glorious Dead'. A carved laurel wreath is at the base to signify victory and the date 1914–1918 is also carved. The most recent names on it are Thomas Collins, Borneo (1966); Derek W. Green, Northern Ireland Conflict: The Troubles (1988); Private Kenneth Preston, Falklands War (1982); Christopher J. Davies, Afghanistan War (2010).

Twenty-four 'Silent Soldiers' were installed throughout the borough in 2018 to mark the Armistice centenary and commemorate British and Commonwealth soldiers who served in First World War. The project was organised by the Royal British Legion. Many of the silhouetted figures are near train stations, highlighting that many soldiers were given a train ticket to return home. Others have been placed in parks and along the roadside as a reminder that returning soldiers could been seen across fields and along roads when returning home.

Silent Soldiers.

Second World War

A total of 469 names of Second World War casualties were added to the cenotaph to remember those who lost their lives fighting for their country. Bombing raids meant there were many civilian casualties in the war, and St Helens was no exception. St Helens was in prime position for bombing raids as it was on the flight path to Liverpool, which was heavily bombed. German bombers would often offload their bombs either flying to or from the city. The Blitz started in London on 7 September 1940, but St Helens was already suffering one of its own. On Thursday 5 September Henry Whitehead (forty-five) was killed at No. 81 Langtree Street, Charles Green (fifty-one) died in Gaskell Street, James Boham (fifty-five) died in Jackson Street and John Burke (forty-eight) died in Sankey Street.

The following evening Samuel Buckley (seventy-three) died at No. 19 Farnworth Street; Mary Elizabeth Tunstall (fifty) died at No. 17 Farnworth Street; and just a short distance away Vera (Veronica) Cassidy (fourteen) was killed when a bomb hit her home at No. 69 Charles Street. Her mother, May, was badly injured, but her brother George walked away uninjured. On 10 September Martha Smith (sixty-two) and her two children Francis (thirty-two) and Veronica (twenty-six) died at No. 31 Talbot Street after a bomb raid. The next fatalities were John Varley (sixty-four) and his wife Elizabeth (sixty-one) who died at No. 31 Newton Road, Parr, on 19 October 1940.

Other civilians who died were Ieuan Griffith Jefferys (thirty-one), a constable with St Helens Borough Police who lived at No. 42 Inman Street, Parr, and died on 8 May 1941; Jesse Harold Shepherd (thirty-seven) a fire-watcher of No. 25 Annie Road who died on 8 May 1941; and William Heyes Fairclough (sixty-one) of the ARP Rescue Services who died on 31 October 1943.

Firemen Robert Jones (thirty-five) and Clifford John Little (thirty-three) were both injured in an incident at Prescot Road in April 1945 and died later at the Providence Hospital. The last listed casualty is Cecil Hand (thirty-eight) of Kiln Lane who died on 12 June 1945.

However, not all St Helens casualties died in the town. Three probationary nurses – Margaret Mary Lowery (nineteen), Rose Helen Moffatt (nineteen) of Reginald Road and Helen Sheridan (eighteen) of Belvedere Avenue, Sutton – were all killed in the bombing of the Royal Salford Hospital on 2 June 1941. They died alongside eleven other probationary nurses and their tutor. They are remembered on the All Saints War Memorial in Sutton.

Walter Ball (twenty-eight), a dispatch rider, was killed at Eccleston Hill on 16 July 1943. His father, also Walter, died in the First World War.

St Helens-born Sidney Ashcroft died at Straubing Prison in Germany on 15 May 1945. Sidney was born on 2 June 1921 to James Ashcroft, who worked at the Sheet Glass Works, and Charlotte Reeves from Tunbridge Wells. They lived in Ashcroft Street. His father served in the First World War but had difficulty holding down a job. Sidney's sisters, Hilda and Margery, died young and were buried in paupers' graves at St Helens Cemetery.

When James deserted the family in the early 1930s, Sidney and his mother moved to Guernsey. During the German occupation they worked in the greenhouses. At the age of twenty Sidney stole food from the Germans. When stopped by two German soldiers it is said that Charlotte tried to intervene; she was pushed by them and then Sidney was

punched. He retaliated and for this he was convicted by court martial on 14 May 1942. He was sentenced to two years and nine months' hard labour.

He was sent to a Jersey Prison and then to several prisons in France and Germany, ending up at Strauberg Prison, 87 miles from Munich. He was last seen alive on 23 April 1945 when thousands of sick and starving prisoners were forced to march to the notorious Dachau concentration camp. At the time it was thought that Sidney and the others were being taken to the gas chambers. However, the mystery of his fate was solved when a post-mortem certificate was found stating that he had died of tuberculosis of the lungs and larynx at Strauberg Prison's hospital a week after VE day. Recently his grave was found in St Michel's Cemetery, Straubing, where a plaque naming him as a 'Guernsey Political Prisoner' has been placed.

St Helens men went to fight in the Spanish Civil War (1936–39). These included Bill Feeley, Sam Wild, Fred Copeman, George Cornwallis, Johnny Monks, P. Martin, J. Nixon, T. Carisle, B. McCormick, S. A. Johnson and Syd Booth, who sustained multiple wounds. It is believed another man, Jim Johnson, was sent home because he had a weak heart. It is reported that Bill Feeley was the last British soldier to fire a shot in anger against Franco in Spain in 1938. The men were members of the International Brigade, which was formed to fight fascism in 1936. When the British battalion arrived back in London on 12 December 1938, they were met at the station by Mr C. R. Attlee, then Labour Party leader and who became prime minster in 1945. There is a plaque commemorating those who fought in the Spanish Civil War in the Town Hall foyer.

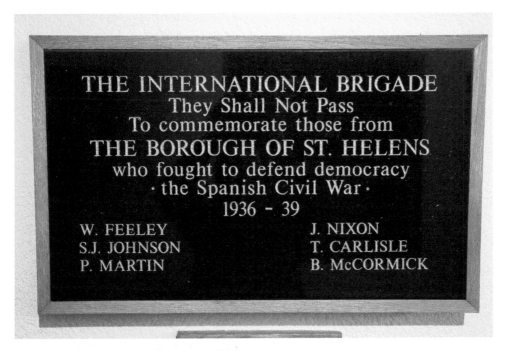

Spanish Civil War plaque in the Town Hall foyer.

St Helens military personal served in the Falklands War, where Private Kenneth Preston was killed. St Helens-born Jeffery Glover became the only prisoner of war when he was shot down while on a reconnaissance mission in Port Howard. He was released at the end of the war. He was born in St Helens, raised in Dentons Green and attended Cowley School.

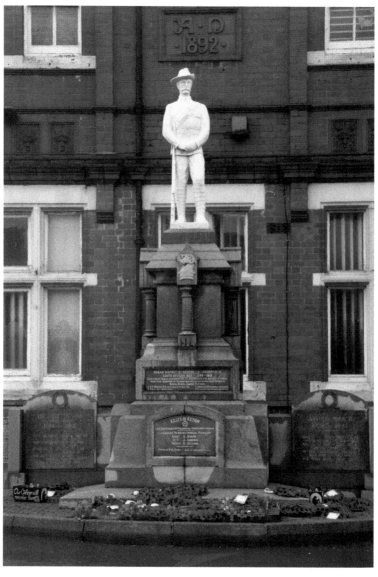

The Newton-le-Willows war memorial is alongside Earlestown Town Hall building and was erected to honour those men from Newton-in-Makerfield who served in the Boer War, South Africa. It was unveiled by Lord Newton on 29 April 1905. Plaques have since been added for those who served in the First and Second World Wars.

9. Buildings and Historic Sites

Billinge Hill, also known as 'Billinge Lump', is the highest point in St Helens and Merseyside, standing at 179 metres or 587 feet. On a clear day Snowdonia, Winter Hill, Manchester, Derbyshire Peaks, Blackpool Tower, Widnes, Runcorn and even the telescope at Jodrell Bank can be seen. It is one of the 176 hills graded as a Marilyn in England.

On top is an eighteenth-century beacon tower originally built as a summerhouse for Winstanley Hall. It was used by the Royal Observer Corps and there was a bunker here. During and after the Second World War it was used for aircraft observation and the bunker was to be used to monitor the location of nuclear blasts and fallout over Lancashire in the event of a nuclear blast. This post was operational from 1960 to 1968.

The photographs of former mayors are displayed in the corridor leading to the Mayor's Parlour.

The Mayor's Parlour.

There have been two St Helens Town Halls. The first was in Naylor Street, in the Market area of town, and suffered two fires, resulting in its closure in 1871. It was replaced by the present Town Hall, which opened its doors in June 1876. The frontage extends for 200 yards, and left of the main block is a gateway with 'Borough Police 1875' over the arch. This is the entrance to the former police yard and parade ground; it is now a car park. The Town Hall is flanked by two iconic K6 Grade II listed phone boxes designed by the renowned architect Sir Gilbert Giles Scott, dating from 1935.

It hosted speakers, singers such as Dame Clara Butt, meetings, dances and concerts. Sir Thomas Beecham made his debut as a conductor here with the Halle Orchestra in 1899. On 9 June 1913 disaster struck when the spire of the Town Hall was set on fire by a workman's blowlamp. The building was being refurbished for the visit of George V that year. Among the areas that were destroyed were the spire and Assembly Room. It was restored to its former glory, minus the spire, and has continued to be at the heart of St Helens.

The Mayor's Parlour contains, among other pictures, Pear's Soap advertisements from 1891, 1892 and 1894; a freedom of the borough scroll; and the royal signatures of George V and Queen Mary, George VI, and Elizabeth II and Prince Phillip.

DID YOU KNOW?
The mace is the official symbol of the mayoral office. It is at the front of the mayor's table during all visits and in front of the mayor on all council meetings, otherwise they would not be recognised. The mace derives its existence from the fact it was a weapon of war and became a symbol of office when the mayor was also a tax collector and would use it for defence. It is carried by the mayoral attendant and no one except the monarch can come between the mace and mayor.

The Mansion House, Victoria Park, was originally Cowley House and was built on the instruction of local solicitor John Ansdell from 1849–50. As reflected in the commission of this beautiful house, Ansdell had been very successful. Following his business partner Richard Speakman's death, he took over the practice and married Speakman's widow. This made him part of the brewing and coal-owning Speakman family.

Cowley Hill was then outside the town and had better housing; none better than this Italianate villa by Charles Read that Ansdell had built. The family moved here in 1851. The house contained a library, dining room, drawing room and its own dairy. There were ten upstairs bedrooms, a dressing room, but only one bathroom. The grounds contained a grotto, lake with its own boathouse, provision for croquet, badminton, archery, bowls, tennis, cricket and a conservatory. John Ansdell remained here until his death, after which his widow left to live with her sisters in Rainhill.

The Cannington Shaw site is bounded by the St Helens Linkway, Tesco superstore and St Helens RLFC Rugby Stadium. The rear of the site houses the former Number Seven bottle-making shop, built around 1886 with a Siemens tank furnace heated by producer glass. Bottle making had been in St Helens before the 1750s, with a bottle house in Thatto Heath that was bought by Francis Dixon-Nuttall and brother-in-law John Merson in 1845. They also built a small glasshouse near the canal terminus at Ravenhead and Merson sold his shares. Nuttall & Co. amalgamated with Cannington Shaw Seven Co. in the 1850s. This was to become United Glass Sherdley Works and by 1889 they employed 870 people.

In 1869, Francis was involved in legal action regarding patenting and lost the case to John Cannington, a Bristol man who had come into the industry here in 1866 when he

A look back at the Mansion House when it was the museum.

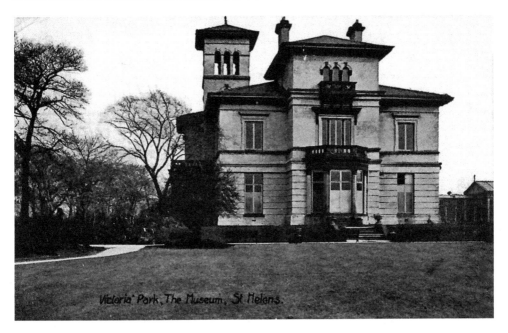

Victoria Park, The Museum, St Helens.

went into partnership with Edwin Cannington and John Shaw. In 1870 their furnaces made the town the national centre of bottle making, and by 1892 they employed 1,188 men and women. It was the largest works of its kind worldwide. In 1913, they amalgamated with five other bottle manufacturers to form United Bottle Manufactures Ltd, known as UGB. Soon the Number Seven shop was no longer used, and by 1918 it was just a shop. It was used as an air-raid shelter during Second World War and survived the 1982 redevelopments. Now identified as 'at risk' by English Heritage, the Friends of Cannington Shaw was founded in 2015 for the preservation and community usage of this historic building. Today Cannington Shaw is a Scheduled Ancient Monument classed as 'the best surviving example in the country of a tank furnace glass shop'.

Vulcan Village and Works is 1 mile north of Newton-le-Willows and is an excellent example of a planned village. It was built by philanthropic industrialist Charles Tayleur, a Liverpool-based railway engineer, for rail employees during the nineteenth century. Vulcan Locomotive Works was founded by Tayleur in 1830, who collaborated with Robert Stephenson at the Vulcan Works in 1832. It was located near the previously completed Liverpool to Manchester line and the works aimed to produce rolling stock based on Stephenson's prize-winning *Rocket*, and in 1832 two locomotives were delivered. They produced locomotives for home and British colonial markets overseas and accordingly the workforce expanded between 1830 and 1833. In 1847 it became the

Cannington Shaw today is a Scheduled Ancient Monument classed as 'the best surviving example in the country of a tank furnace glass shop'.

Vulcan Foundry Company and became a limited company in 1864. In 1898 the name was changed to the Vulcan Foundry Ltd.

It is likely work began on the village in 1832 and it was established in 1835, although it is thought there was a settlement here before then. Designed by Tayleur and Stephenson with houses arranged in terraces around a triangular green, itself encompassed by the railway to the west, factory to the north and east and agricultural land on the south. In the 1840s three terraces were added to the north side, resulting in 114 properties. On the village green was the school (1859), Vulcan Hostelry, Vulcan Inn and bath/washhouse.

In 1956, Vulcan Works ceased trading although the railway heritage lived on through the new owners, the GEC Diesel Company, who's subsidiary company, Rushton Diesels Co., produced locomotives here until 1982.

In 1975 and 1977 there were moves to demolish the village, which resulted in the 'Save Vulcan Village Campaign' being launched with the backing of local MP John Evans. The village survived and in 1982 it was one of a few privately owned villages nationwide. Today it is a conservation area.

It is thought that Eccleston Smithy Heritage Centre dates to the early nineteenth century, although it has not always been in the same location. This changed in the 1930s when Whiston Urban District Council wanted to demolish the Smithy to make way for a library (now the Village Hall) and public toilets. After strong protests the council agreed to take down the Smithy and rebuilt it on its current site. The Hall family occupied the Smithy and worked as farriers and blacksmiths, shoeing a wide range of horses. By 1994 this building was falling into disrepair when Eccleston Parish Council bought it and turned it into Eccleston Smithy Heritage Centre.

The World of Glass museum, which opened in 2000, is built over the remains of the Daglish Foundry, which was established in 1798. Their Glass Roots Gallery explains

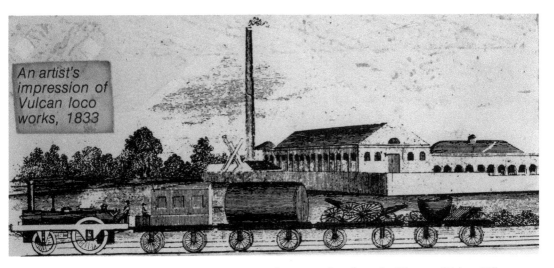

An artist's impression of Vulcan Locomotive Works, 1833, taken from the *History of Vulcan Village and Foundry* by W. Fairhurst (*c.* 1940).

Vulcan Foundry.

DID YOU KNOW?
The legacy of Vulcan Foundry lives on through street names such as Tayleur Terrace, Stephenson Road and Gooch Drive, which is named after Sir Daniel Gooch, a notable railway engineer.

the history of glass with artefacts dating back to 3000 BC. The Earth into Light Gallery traces the history of St Helens and its role as a worldwide glass giant. It recreates life in a Victorian town with its St Helens Past section. There are Victorian furnaces and underground tunnels that show the world's first continuous glass-making furnace, built in 1887 by William Windle Pilkington. There are also live glass-blowing demonstrations.

DID YOU KNOW?
In 1948, St Helens became twinned with Stuttgart, becoming the first English town to partner with a German town after the Second World War.

10. Famous People

St Helens has had many notable people who have been born, educated, worked, lived or performed here. There have also been some who have made their name by being disreputable, such as mass-murderer Frederick Bailey Deeming. Deeming was born in Ashby-de-la-Zouch, Leicestershire, on 30 July 1853 and was a 'difficult child'. He ran away to sea at sixteen and began his career in crime. He moved to Australia in 1882 with his wife Marie, née James, whom he had married in Lower Ince in 1881. Coincidently, Deeming's brother Alfred married Marie's sister, Martha.

When they returned to England in 1888, they had two children, Bertha and Marie. Despite this, under the name of Harry Lawson, he bigamously married twenty-one-year-old Helen Matheson in February 1890. A month later he disappeared from her life.

He visited Marie and their four children in Birkenhead before going to South America, but he was arrested in Montevideo and extradited to England and charged with 'obtaining goods by false pretences'. He was convicted and sentenced to nine months in prison.

In July 1891 Deeming found himself living in a hotel in Rainhill as Albert Williams where it is thought Marie joined him. Deeming leased Dinham Villa, saying it was on behalf of his friend 'Colonel Brookes', but it was Deeming who moved in. He was joined by his family but told everyone Marie was his sister. Shortly afterwards Deeming supervised work on replacing the kitchen floor, saying the house drains were defective. Deeming started wooing Emily Lydia Mather, daughter of widowed local shopkeeper Mrs Dove Mather. Deeming, as Albert Williams, married her on 22 September 1891. In November 1891 they went to Melbourne where they rented a house in the suburb of Windsor. The marriage was to be short-lived, however, for on Christmas Eve/Day he murdered her and buried her under one of the hearthstones in a bedroom. On 3 March 1892 a prospective tenant complained about a 'disagreeable smell' in the second bedroom. The hearthstone was removed and Mather's body was discovered. Meanwhile, Deeming had been busy swindling a Melbourne jeweller and approaching Holt's Matrimonial Agency as 'Duncan', another alias, wishing to meet a suitable wife.

Deeming was arrested at Southern Cross, Australia, on 12 March 1892 and this sparked a search of Dinham Villa. There they discovered the bodies of Marie and the four children Bertha (ten), Mary (seven), Sidney (five) and Leala (eighteen months). Deeming was hanged on 23 May 1892 at Old Melbourne Gaol, Australia.

However, not everyone who was hanged was guilty, as illustrated by Isabel Robey who was born and lived in Windle township. On 19 August 1612, she was tried as a witch with the famed Lancashire Witches, following a journey that began on 12 July 1612 when her accusers were examined before Sir Thomas Gerard. Her main accuser was Peter Chaddock, her goddaughter's husband, of whom Isabel strongly disapproved. Her other accusers, her neighbours, were Jane Wilkinson, Margaret Lyon and Margaret Parre, who

were also examined on that date. After this examination she was sent to Lancaster Castle where she was found 'guiltie of the Fellonie by Witch-craft', and although no murder or death had occurred, she was hanged on 20 August 1612.

DID YOU KNOW?
In 1927 William and Nora Carter of Hardshaw Street won the Republic of Ireland Old Time Dancing Championship. They were the first couple in the history of dancing to bring home a world championship trophy. Nora Carter had a dance studio in North Road.

Richard John Seddon was the eighth prime minister of New Zealand and was born at Eccleston, St Helens, on 22 June 1845. He is their fifteenth prime minister and is regarded as one of their greatest political figures, changing the face of New Zealand forever. He was a social reformer and was sometimes known as 'King Dick' for his autocratic style practised during his thirteen-year premiership.

Richard Seddon got off to a rather less-auspicious start in life despite both his parents, Thomas Seddon and Jane Lindsay, being teachers. He was described as unruly and was removed from school when he was twelve. However, Seddon had become interested in engineering and after a brief spell working at Barrow Nook Hall Farm, he started work at Daglish's Foundry, St Helens. After working at the Vauxhall Foundry, Liverpool and armed with a Board of Trade Certificate as a mechanical engineer, at sixteen he emigrated to Australia aboard the SS *Great Britain*.

While working in Melbourne railway workshops he caught 'gold fever' and went to try his luck at Bendigo without success. He became engaged to Louisa Jane Spotswood, whose family would not allow their marriage until Seddon became more financially successful. The couple eventually married and have nine children, including Tom Seddon, who succeeded his father as MP for Westland.

In 1866, Seddon moved to the west coast of New Zealand's South Island. Again, it was gold that was the draw. Soon afterwards Seddon entered local politics and became known along the west coast as a champion for miners' rights and interests. In 1877, he became the first Mayor of Kumara, a town in the gold-mining area.

Seddon first sought election to the New Zealand House of Representatives in 1876, standing for Hokitika, where a statue of him stands today. He was unsuccessful then, but in 1879 entered the House of Representatives where he followed an anti-elitist policy. In 1890, he joined the Liberal Party as he saw them as champions of 'the common man'. He became president in 1893 and was instrumental in women's suffrage, introducing alcohol licensing districts and his Old Age Pensions Act of 1898, which formed the basis of their welfare state. Seddon was a great supporter of the British Empire, although he twice refused a knighthood, wanting to remain a man of the people. He attended Queen Victoria's Diamond Jubilee, received her Jubilee Medal and was appointed to the Privy Council. While

Richard Seddon's cottage.

attending the coronation of Edward VII and Queen Alexander he received his Coronation Medal. He visited St Helens in July 1902 and received the freedom of the borough.

In 1906, aged sixty, Seddon died of a massive heart attack on the ship *Oswestry Grange* while returning from Australia to New Zealand. He is buried in Wellington, New Zealand. In March 2016 the New Zealanders voted, in a referendum, to keep their national flag which was introduced under Seddon's premiership in 1902. Closer to home there is a memorial to Richard Seddon in St Paul's Cathedral, London, while St Helens still celebrates his legacy with Seddon Street, Seddon Close, Eccleston and Seddon Suite at St Helens Hospital.

Three-times Oscar winner George Groves was born in Duke Street in 1901 and was educated at Ravenhead School, Cowley Grammar and finally graduated from Liverpool University. In 1923 he emigrated to New York and began working as a researcher developing film sound technology at Bell Laboratories. When his employer was taken over by Warner Brothers he was seconded to Los Angeles where he would move to in 1927. In this year he worked on the soundtrack of *The Jazz Singer* with Al Jolson, the first film with synchronised dialogue, marking the end of silent films. He won three Oscars

for *Yankee, Doodle, Dandy* in 1942, *Sayonara* in 1957 and *My Fair Lady* in 1964. He died in 1976 and is buried in the Forest Lawn Cemetery, Hollywood Hills.

Oscar-winning writer Colin Welland has strong connections with St Helens. He was born in Liverpool in 1935 to the Williams family, who moved to Newton-le-Willows where he attended Newton Grammar School and later became a teacher. He became an assistant stage manager for Manchester Library Theatre, leading to the role of PC David Graham in *Z Cars*, which lead to the role of Mr Farthing in *Kes* for which he won a BAFTA. He acted alongside Richard Burton and Dustin Hoffman but was also known as a writer, winning a BAFTA for *Kisses at Fifty*. He won an Oscar for the best original screenplay for *Chariots of Fire* in 1982. He died in 2015 aged eighty.

Born in 1947 Willy Russell is another playwright linked to the town having started his working life at a hairdresser's in Barrow Street from which he was sacked. After teacher training, he had his first success in 1974 with *John, Paul, George and Ringo and Bert* at the Everyman Theatre, Liverpool. He was commissioned by the Royal Shakespeare Theatre to write *Educating Rita* and this was followed by other successes such as *Blood Brothers* and *Shirley Valentine*.

Hollywood actor Herbert Mundin was born in St Helens on 21 August 1898 and lived in Windleshaw Road before moving to St Alban's where the family home was called St Helens Villa.

After the First World War Herbert began his acting career in touring repertoire companies, moving on to the Prince of Wales Theatre, London. In the 1920s he performed in New York, Australia and New Zealand, and made his first film appearance in 1928 in *Bulldog Breed*. His desire to appear in talkies resulted in his move to America in 1931. He made many Hollywood films including *Mutiny on the Bounty* with Clark Gable and Charles Laughton in 1935 and *The Adventures of Robin Hood* in 1938 with Errol Flynn. He died in a car crash in 1939.

Robert Dorning was born on 13 May 1913 and lived at Croppers Hill and Pigot Street. He was one of the candidates to play Captain Mainwaring in *Dad's Army* before Arthur Lowe was awarded the role. He trained in ballet and in 1948 appeared in *The Red Shoes* before becoming a television actor best known for his roles in *Bootsie and Snudge*, *Hancock's Half Hour*, *Coronation Street* and *Emmerdale Farm*. He also made countless films. His daughters Stacey and Kate are both actors. He died in 1989.

DID YOU KNOW?
George Formby, who was to become the country's highest paid entertainer, made his first professional appearance at the Hippodrome, Earlestown. He was billed as George Hoy, his mother's maiden name, on 21 March 1921 on a two-week run for which he was paid £5 a week.

Although Pete Postlethwaite was born in Warrington on 7 February 1946, he was educated at West Park Grammar School. He began acting at the Everyman Theatre and appeared in film and television. He was a member of the Royal Shakespeare Company

Robert Dorning.

and received an Oscar nomination for his role in *In the Name of the Father* in 1993. After his performance in *The Lost World: Jurassic Park* Steven Spielberg billed him as 'the greatest actor in the world'. He died in 2011.

Actor David Moorst was born at Billinge Hospital on 9 April 1992 and was brought up in Haydock. He was educated at Merton Bank Primary School and Cowley High School before studying at LAMDA. His roles include Joseph Ogden in the film *Peterloo,* directed by Mike Leigh in 2018.

Among the comedians born in St Helens are Bernie Clifton and Johnny Vegas. Well-known writers, including Frank Cottrell Boyce and Ray Connelly, and singers Jackie Abbott from Beautiful South and Rick Astley were also born here.

During the 1980s celebrities such as Bill Shankly, Joe Mercer, Alan Kennedy, Geoff Hughes, Anne Kirkbride and George Roper were regular visitors to the town supporting the RNIB's Pile of Pennies campaign.

Bibliography

Books

Barker, T. C. and J. R Harris, *A Merseyside Town in the Industrial Revolution: St Helens 1750–1900* (London: Frank Cass, 1954)

Hart, Roger, *Vintage St Helens and District* (Nelson: Hendon Publishing Company Limited, 1976)

Morris R. J. B., *A Short History of St Helens Parks* (1976)

Norcross, Derek, *The Provision of Education in the St Helens Area 1833–1902* (Manchester, 1973)

Presland, Mary, *St Helens: A Pictorial History* (Chichester: Philmore & Co. Ltd, 1995)

Risley, David and Richard Waring, *St Helens Pals* (St Helens Townships History Society, 2014)

Senior, Geoffrey and Gertrude Henin, *St Helens As It Was* (Nelson: Hendon Publishing Company Limited, 1973)

Sheen, Frank, *St Helens in the Making* (Coventry: Jones-Sands Publishing, 1993)

Sheen, Frank, *The Way We Were* (Wirral: Jones-Sands Publishing, 1995)

Websites

ludchurchmyblog.wordpress.com/places-further-afied/crank-caverns

sthelens.gov.uk/sthelens/history/history.nsf

sthelens.gov.uk/enviromental-services

sthelensrollsofhonour.co.uk

suttonbeauty.orguk/suttonhistory